IMAGES
of America

THE POLISH COMMUNITY OF NEW BRITAIN

D1591185

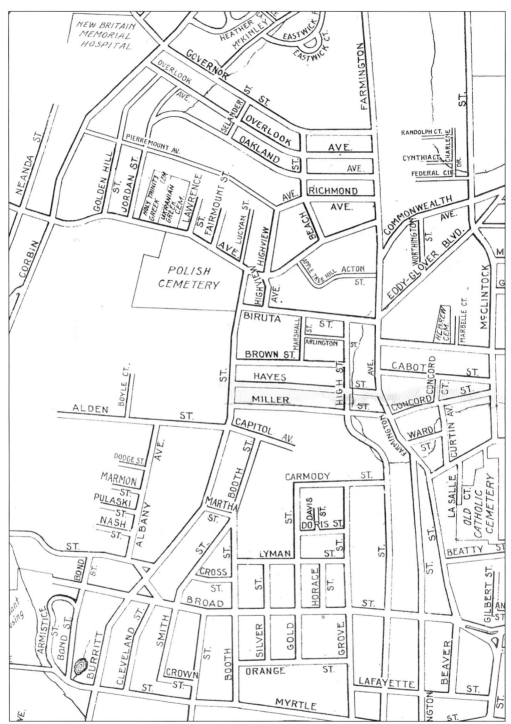

This map illustrates the area of the greatest concentration of Polish settlement in New Britain. The development of Polonia began in the 1890s and was centered on Broad Street. By the 1930s, the Poles were well established in the northwest section of the city. From Myrtle Street, just west of downtown, the Polish streets extended north between Farmington and Corbin Avenues.

IMAGES
of America

THE POLISH COMMUNITY OF NEW BRITAIN

Jonathan Shea and Barbara Proko

ARCADIA

Published by Arcadia Publishing,
Charleston SC, Chicago IL, Portsmouth NH, San Francisco CA

Printed in Great Britain

Library of Congress Catalog Card Number: 2004117377

For all general information, contact Arcadia Publishing:
Telephone 843-853-2070
Fax 843-853-0044
E-mail sales@arcadiapublishing.com
For customer service and orders:
Toll-free 1-888-313-2665

Visit us on the Internet at www.arcadiapublishing.com

No man may love the beauty of his race
unless he knows the path by which he came
unless he knows that blood-soaked, hallowed place where
histories of the ages call his name: where
footsteps of his fathers traced the soil from
sun's arising to the last moon's wane …

Victoria Janda, *The Heritage*

To my grandmother Zofia Kryszczynska Bryzgiel, a native of Chrzanowo Cyprki, province of Lomza, who passed to me her language, her songs, her village food, her Old World customs, and most of all, her wisdom and strength crafted and developed over the 100 years she spent on this earth.
—Jonathan D. Shea

To the Sisters of the Holy Family of Nazareth, who gave of themselves so generously in teaching thousands of Polish American students at Our Lady of Czestochowa Parish in Worcester, Massachusetts, between 1915 and 2004.
—Barbara Proko

Authors' note: The typeface used in this book does not allow the representation of diacritics used in the Polish language.

CONTENTS

ACKNOWLEDGMENTS

For invaluable assistance, information, and materials, we are indebted to Msgr. Daniel Plocharczyk, Rev. Brian Shaw, and Sr. Mary Christine Jachdowik, along with Peter Bartlewski, Virginia Blanchfield, Patricia Conroy, Lawrence Hermanowski, Florence Kaliszewski, Richard and Helen Klecha, William McNamara, Andrew and Diane Mechlinski, Barbara Misko, Jan Niebrzydowski, Wanda Nowakowska, Arlene Palmer, Christine Stoj, Patricia Watson, and Ewa Wolynska.

For generously sharing their treasured photographs and memorabilia, we are grateful to Valerie Altgiebiers, Patricia Anderson, Mieczyslaw Bajek, David Charette, Wanda Dabrowski, Veronica Danek, Irene Dasenbrock, Danuta Depa, Henry Deptula, Andrew Dignazio, Antoni Dudanowicz, David Dzilenski, Edward Dzwonkowski, Susan Earl-McCarthy, Mary Ann Forgione, Kazimierz Garbowski, Bogumila Gladysz, James Golon Jr., James Golon Sr., Zofia Gorska, Eva Gryk, Henrietta Henclewski, Thomas Hermanowski, Romualda Kaczynski, Barbara Kirejczyk, Veronica Koczera, Ruth Kozlowski, Florence Kragiel, Diana Kurz, Stanley Kusinski, Mitchell Kusy, Mary Ann Kwasnik, Wlodzimierz Lausch, Edmund Liszka, Joseph Maciora, Robert Majewicz, Dorothy Majewski, Raymond Matyszczyk, Rosalie Mehan, Wanda Mercier, Margaret Miklosz, Ike Moranski, Dora Narzymski, Jan Niebrzydowski, Irene Niewinski, Constance Ochnio, Regina Puzanowski, Lucian Repczynski, Sophie Rogoz, Eugene Rosol, Sr. Mary Alma Sakowicz, Daria Savickas, John Seremet, Jean Sharka, Andrzej Stachowiak, Krystyna Slowikowska-Farley, Stanley Sternal, Dominik Swieszkowski, Jessica Szczepankowski, Diane Szepanski, Zofia Szewczak, Ludwik Szydelko, Helen Thompson, Joseph Veneziano, Ron Wakefield, Kathleen Webber, Maryanne Welna, Jeanne Wischenbart, Regina Wolodkowicz, Elizabeth Zyla, and Lucian Zysk.

For allowing the use of materials from their archives, we thank the Connecticut Polish American Archive and Manuscript Collection at Central Connecticut State University, the Daughters of Mary of the Immaculate Conception, General Jozef Haller Post 111 of the Association of Polish Army Veterans, Holy Cross Parish, the New Britain *Herald*, the New Britain Police Department, the New Britain Public Library, the New Britain Sports Hall of Fame, the Polish American Foundation of Connecticut, the Polish Genealogical Society of Connecticut and the Northeast, Polish Falcons Nest 88, the Pulaski Democratic Club, Sacred Heart Parish, Sergeant Joseph Sakowicz Post 1 of the Polish Legion of American Veterans, and the TGM Northwestern Veterans Club.

For informing the public about this project, we are grateful to the *Hartford Courant*, the *Herald*, the *Nowy Dziennik*, the *Przeglad Polonijny w Connecticut*, and the *Polski Express*.

Finally, we thank Arcadia Publishing, whose commitment to preserving local history makes this book possible.

INTRODUCTION

Polish immigrants began settling in New Britain in the 1890s, drawn by factory jobs at well-established metal-products companies such as Stanley Works, Landers, Frary & Clark, and North and Judd. They came *za chlebem* (for bread) or for the promise of an economically better life. Nearly two-thirds came from Russian Poland, predominantly from Dabrowa, Bialostocka, and Myszyniec parishes. Many others came from the Wola Ranizowska area in Austrian Galicia. What began as a trickle swelled to a flood. By 1910, New Britain had established itself as the Hardware City of the World, and the Poles had established themselves as the city's largest ethnic group. Census figures indicate that the Poles constituted about 15 percent of New Britain's population by 1920.

Most of the immigrants began their new lives as unskilled laborers. Because their wages were low, finding cheap, convenient housing within walking distance of the factories was a priority. They settled in tenements that dotted Broad, High, Grove, Orange, and Myrtle Streets and set their sights on the area's expanse of undeveloped land, buying lots and building their own multi-unit homes as soon as their incomes allowed. Meanwhile, other Poles opened shops and provided services to meet the growing neighborhood's needs. By 1925, Broad Street was lined with businesses such as the Polish People's Savings Bank, Zujko's Paint Store, and Bryzgiel's Market, along with organizations such as the Polish Political Club No. 1 and the Polish Falcons. To this day, Broad Street is widely recognized as the main street of Polish New Britain.

Among Polonia's emerging institutions, the single most important was Sacred Heart Parish. Establishing their own parish and simultaneously reestablishing the social patterns and customs they had known in Europe were the Poles' primary concerns. In 1894, they built the modest wooden Sacred Heart Church on Orange Street. In 1895, Rev. Lucjan Bojnowski, a Dabrowa parish native, arrived to serve as pastor. He ministered to his people's religious and material needs until his death in 1960. During his 65-year pastorate, Bojnowski dominated New Britain's Polish community to an extent that remains unparalleled.

Visionary and ambitious, Bojnowski wanted to provide a comprehensive range of services and structures that would accommodate his people from cradle to grave. He immediately established several parish societies, and in 1896 he established Sacred Heart School. In 1904, he founded Our Lady of Rozanystok Orphanage and an order of nuns, the Daughters of Mary of the Immaculate Conception, to staff it. Both remain unique; they are the only such Polish institutions ever founded in New England. That same year, Bojnowski oversaw the construction of the magnificent Gothic stone Sacred Heart Church on Broad Street. It was built to replace the original church, which the congregation had already outgrown. He also founded *Przewodnik Katolicki*, a Polish-language newspaper and printing and publishing house. In 1912, he

established Sacred Heart Cemetery. The largest Polish cemetery in New England, it is the only one that observes *Dzien Zaduszny* (All Souls' Day) traditions each November. Bojnowski's final construction project was St. Lucian's home for the elderly in 1925. Two other Polish parishes also developed in the city: Holy Cross (Roman Catholic) in 1927 and Transfiguration of Our Lord (Polish National Catholic) in 1941.

In New Britain, as in Poland, the parish was the fountainhead of social, cultural, and political life. In the early days, groups focused on parish needs and experiences and retained a strong European character. By the 1930s, new Polish-oriented but unmistakably American organizations appeared, reflecting varying degrees of cultural assimilation. For example, the Sergeant Joseph Sakowicz Post of the Polish Legion of American Veterans was named in memory of New Britain's first Polish American to lose his life serving in the U.S. Army in World War I. Holy Cross Parish founded a ladies guild, girls' drum corps, and Boy Scout and Girl Scout troops. College-educated professionals founded Club 44. Young women joined the Polish Junior League. Political clubs encouraged immigrants to become citizens and run for office. Their efforts produced five New Britain mayors as well as several state and national legislators of Polish extraction.

Between 1947 and 1955, hundreds of Polish refugees arrived in New Britain from war-torn Europe. Émigré officers, soldiers, and veterans of the Polish Army swelled the membership rolls of the Haller Post. Polish Boy Scout and Girl Scout troops were founded in 1957. *Polska Szkola Sobotnia* (Polish Saturday School), organized in 1960 to teach children language, culture, and history, soon became the largest such school on the east coast. Immigration was continuous, in small numbers, through the 1960s and 1970s. When martial law was declared in Poland in 1981, people escaping Soviet oppression found a welcoming home in New Britain. They infused new blood into existing organizations and established several of their own. In that same era, descendants of the original immigrants established the Polish Genealogical Society of Connecticut to preserve ethnic history.

New Britain's landscape bears witness to the community's century-old Polish heritage with numerous parks, buildings, and roads, including the Sergeant H. J. Szczesny Parking Garage, Kosciuszko Highway, Pulaski Middle School, Copernicus Hall at Central Connecticut State University, Milewski Fountain, Kosciuszko and Pulaski Parks, and two monuments honoring slain Polish priest Jerzy Popieluszko. The Katyn Memorial, which commemorates the thousands of Polish Army officers and intellectuals murdered by the Soviets in 1940, was the first of its kind in the United States.

New Britain's vibrant Polish identity, enhanced for decades by Bojnowski's renown, made it a must-see on the itineraries of European luminaries. Gen. Jozef Haller visited New Britain in the 1920s and 1930s. A large *Witamy* (Welcome) sign greeted Stanislaw Mikolajczyk, premier of the Polish government, in exile during World War II. In 1969, Cardinal Karol Wojtyla, later Pope John Paul II, spoke at both Roman Catholic parishes.

The city's Poles and Polish Americans have always maintained strong ties with *Ojczyzna* (the Fatherland). New Britain's Polonia is a community that holds fast in its memory its spiritual and cultural roots, the long roads its families have traveled, and their struggles and triumphs along the way.

One

LEAVING HOME

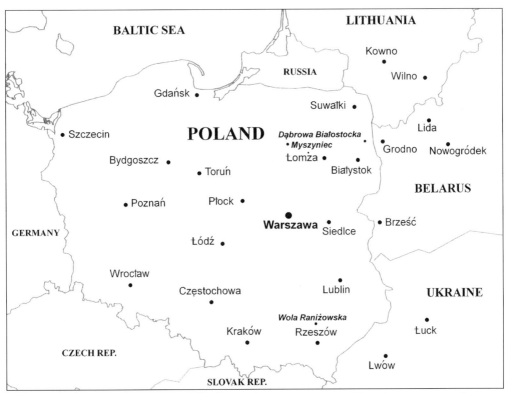

This map illustrates Poland's present borders and major cities, as well as the three areas that sent the most immigrants to New Britain: Dabrowa Bialostocka, Myszyniec, and Wola Ranizowska. Poland's external and internal borders have changed many times during its thousand-year history. Between 1890 and 1914, when millions of Poles left to build new lives elsewhere, Poland was partitioned and occupied by Russia on the east, Austria in the southeast, and Germany in the west.

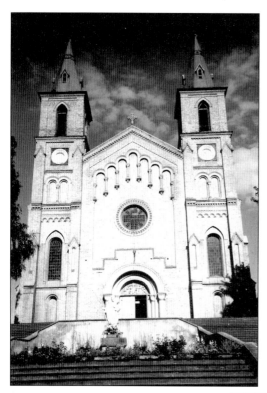

St. Stanislaus Bishop and Martyr Church, built on an elevation in Dabrowa Bialostocka, can be seen for miles in the largely flat countryside that surrounds this town of 6,700 northeast of Bialystok. Founded in 1460, the parish is one of the largest in the area. It has the distinction of sending the most Polish settlers to New Britain in the years before World War I; among them was Lucjan Bojnowski, who became pastor of Sacred Heart Parish.

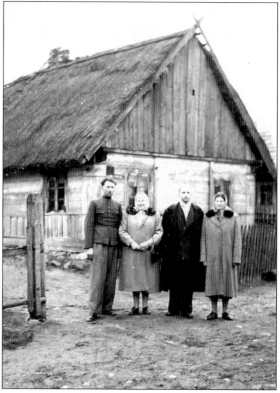

Four siblings stand outside the thatched-roof farmhouse in which they were born in Wesolowo, Dabrowa Bialostocka. Pictured, from left to right, are Jozef Bryzgiel, Wladyslawa Zalewska, Edward Bryzgiel, and Stefania Owsiejko. They are posing for a World War II–era photograph to send to their aunts and uncles in New Britain: Jan and Jozef Bryzgiel, Tekla Kryszczynski, and Rozalia Uchalik. Such farmsteads, common at the turn of the 20th century, have largely disappeared in present-day Poland.

10

The Roman Catholic Church of the Holy Trinity dominates the town square of Myszyniec in this 1937 photograph. This church was the ancestral and spiritual center of many of New Britain's first immigrants, who came from this town and villages such as Dabrowy, Krysiaki, Wolkowe, and Wykrot in the Kurpian Forest area.

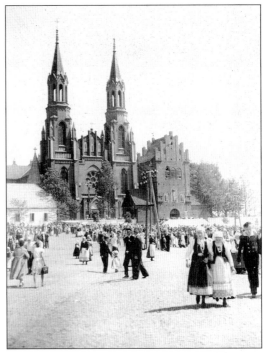

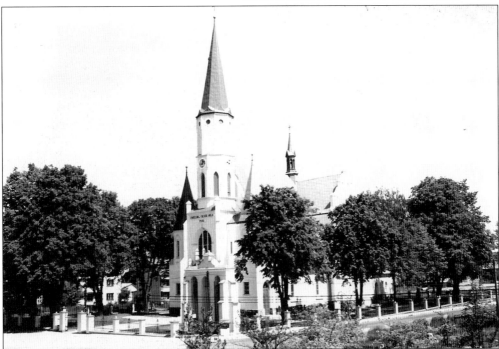

St. Wojciech Roman Catholic Church serves Wola Ranizowska, a village of 2,000 in what was once Galicia (Austrian Poland). The village, once part of the parish at Ranizow, became the site of its own parish in 1919. A significant percentage of New Britain's early Polish immigrants came from Wola Ranizowska. Two of the city's major kielbasa makers, Rosol and Rembisz, trace their roots to this area.

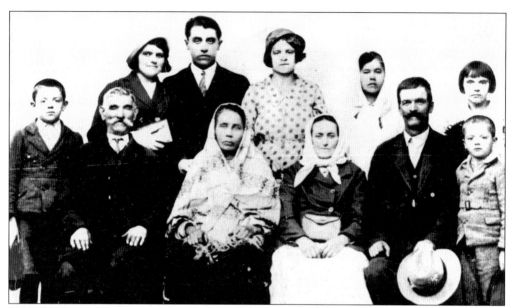

Leon and Rozalia Czarnecka Sternal, their children, and other family members pose for a group portrait in 1933. The Sternals, who resided in Piaseczna, Stryj, were taken to forced labor in Germany by the Nazis during World War II. Identified in the first row are, beginning fourth from the left, Rozalia Sternal, Leon Sternal, and their youngest son, Stanislaw, age six. After the war, Stanislaw served in the U.S. Army; he came to America in June 1950 and began a new life in New Britain.

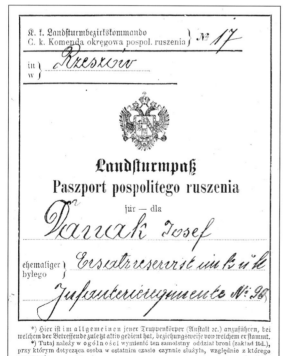

This German-language Austrian passport issued in Rzeszow enabled Jozef Danak (Danek in the United States) to depart his native Grodzisko Dolne in 1910 and seek work in New Britain. Danak completed his military service with the Austrian army in 1909; only then could he obtain a travel document. Small farms, poor economic conditions, and a surplus of rural laborers forced many Galician farmers to emigrate in the decades preceding World War I.

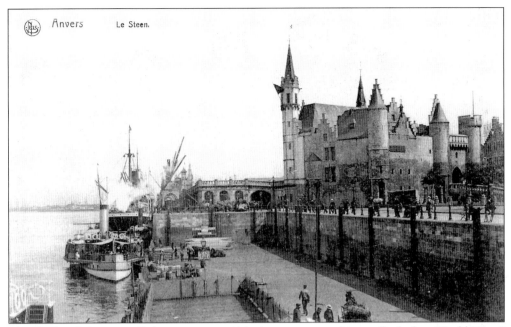

The docks of Antwerp, Belgium, witnessed heavy passenger-ship traffic before World War I broke out in 1914. Approximately one million immigrants, including many Poles, passed through Antwerp by 1905. Other popular ports of departure for Polish emigrants were Hamburg and Bremen, Germany; Rotterdam, Holland; Libau, Latvia; and Liverpool, England.

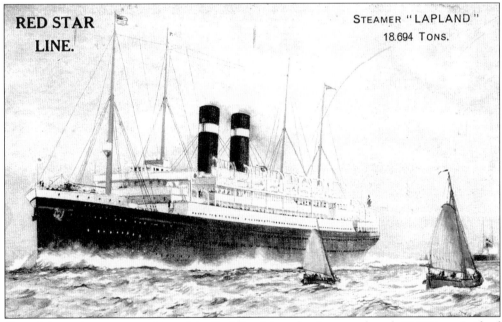

One of the main passenger ships of the Red Star Line, the Antwerp-based, 18,000-ton *Lapland* embarked on its maiden transatlantic voyage in April 1909. A majority of the 2,300 berths available were in the stark, crowded, lower-deck, third-class quarters known as steerage. For peasants and others with limited means, even the $15 to $25 needed for steerage fare was a daunting amount to come by.

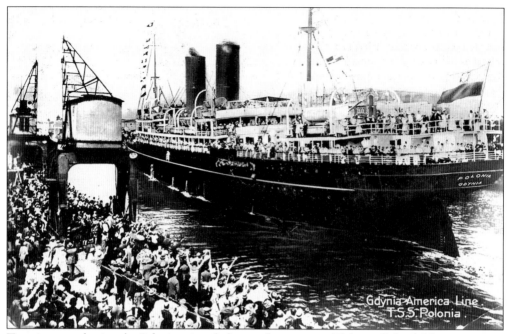

Teeming crowds view the *Polonia* as it sails from its home port of Gdynia, Poland. Upon regaining its independence after World War I, Poland entered the competitive market of transatlantic steamship trade, enabling its citizens for the first time to sail under their nation's flag.

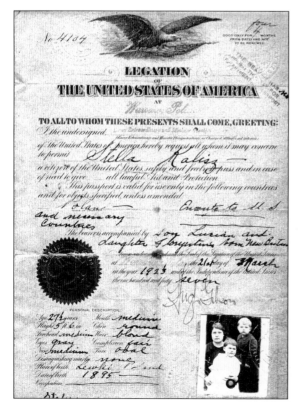

At the conclusion of the First World War, many immigrant Poles left America to return to their now-independent homeland. For some, it was a permanent return; for others, it was a brief visit. This temporary U.S. passport, issued in 1923, allowed Stella (Stefania) Kalisz and her New Britain–born children, Florentyna and Lucian, to travel to Poland and then return to their husband and father, Kazimierz, in New Britain.

To ease the trepidation of facing the unknown alone, immigrants often traveled in groups with friends and relatives. This May 1910 manifest of the SS *Finland* lists the names, albeit many misspelled, of immigrants from the Dabrowa Bialostocka area: Zofia and Rozalia Nachila, Julianna Tarasewicz, Michalina Jurczyk, and members of the Rudzik and Zywno families. They all planned to join family members in New Britain and in Middletown.

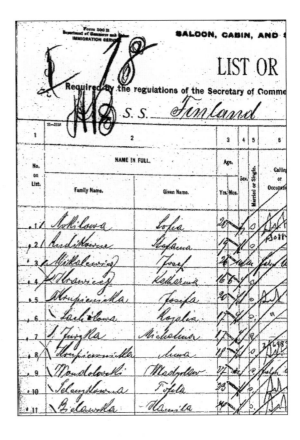

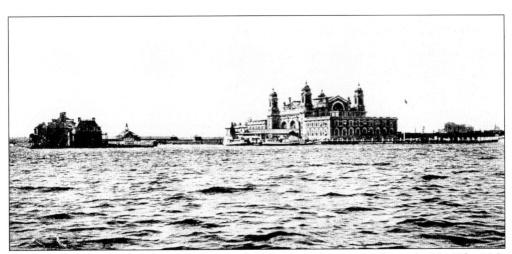

About 12 million immigrants passed through Ellis Island between 1892 and 1954. The U.S. immigration station's Beaux-Arts-style main building is a dominant feature of New York harbor. It was constructed in 1900 to replace the original 1892 building that burned in 1897. In 1990, the main building was reopened as a national monument after extensive restoration.

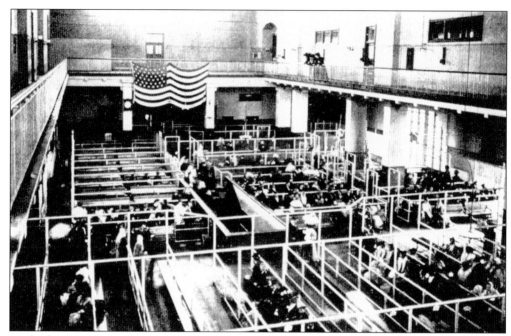

With identification tags pinned to their clothes, immigrants underwent a series of inspections at Ellis Island. Their papers, health, apparent character, and finances were assessed for a determination of whether they would be welcomed to America or sent back home. The time spent waiting in line in the cavernous Registry Room or Great Hall was an anxious experience for newcomers who did not speak English and feared rejection at this final stage in their journey.

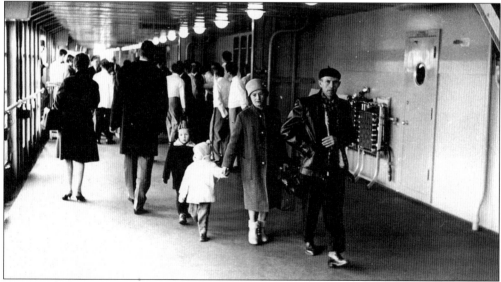

Jan and Regina Wolodkiewicz and their son, Zdzislaw, age 5, and daughter, Lucyna, age 3, stroll on the deck of the ocean liner that brought them to America in the late 1950s. Emigration from Poland to New Britain, in varying numbers, spanned the entire 20th century. The Wolodkowiczes were originally from Polunce, a tiny village about 20 miles northwest of Lida. When Poland's borders changed as a result of World War II, the Lida area was absorbed into western Belarus.

Two
STAYING TOGETHER

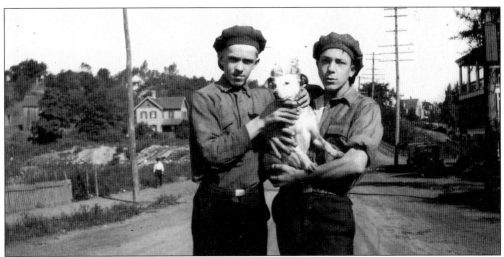

Two unidentified boys and their dog stand in the largely undeveloped Farmington Avenue neighborhood in 1923. During the late 1920s and 1930s, this area became the site of a second Roman Catholic parish, Holy Cross, and new middle-class housing for New Britain's ever-growing Polish community.

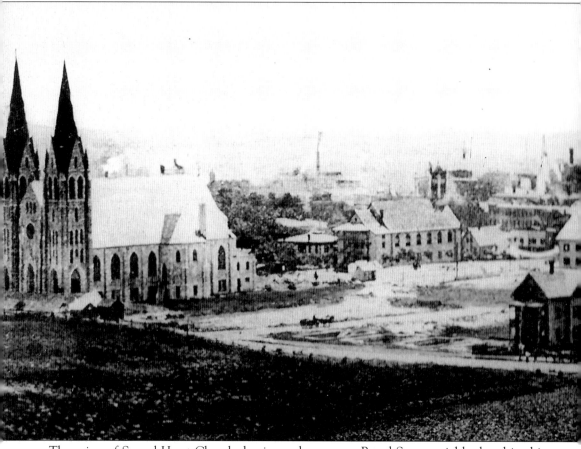

The spires of Sacred Heart Church dominate the nascent Broad Street neighborhood in this 1910 photograph. Visible in the background are the smokestacks of the Russell and Erwin Manufacturing Company at Washington and Myrtle Streets. Also nearby were Corbin Screw Corporation at High and Myrtle Streets and Stanley Works at Myrtle Street between Grove and Booth Streets. The early Polish immigrants settled in areas close to the factories that employed them; these were clustered just outside downtown New Britain. Many of the dwelling units on Orange Street, behind the church, became the first pieces of real estate that the early

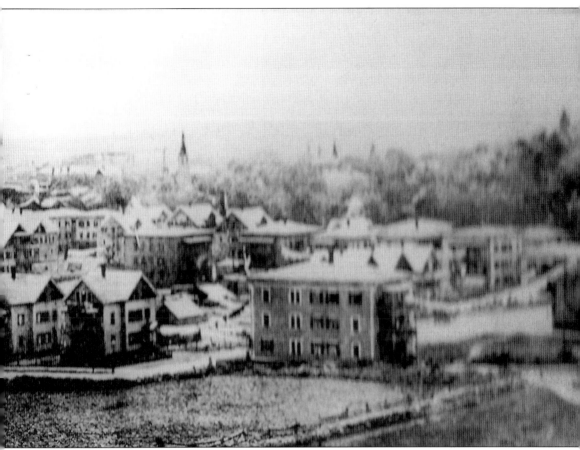

Poles bought in the city. Records identify early property owners here as Kania, Blogoslawski, Kotowski, Bednarczyk, Brodzik, Bojnowski, Kirejczyk, Tomaszewski, Rozanski, Stepien, Parciak, Lozinski, Zumski, and Laskowski. Other Polish landowners were Gieszynski and Wisk on Grove Street, and Mieczkowski and Ostrowski on Myrtle Street. The construction boom that developed the neighborhood's main commercial strip was yet to come. The few buildings pictured to the right of the church are on the south side of Broad Street between Gold and Silver Streets.

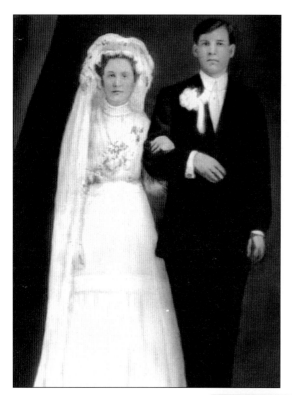

Jan Kazimierz Bryzgiel, age 27, a native of Wesolowo, Dabrowa Bialostocka, poses with his 19-year-old bride, Zofia Jozefa Kryszczynska, on April 15, 1913, their wedding day. Zofia was born in Chrzanowo Cyprki, Przytuly, Lomza. The couple was one of five married that day at Sacred Heart Church. A reception followed at Dudjak's Hall, a popular venue for such occasions.

Stella Koziatek and Stanley Karnasiewicz, New Britain–born children of Polish immigrants, display their wedding finery in this October 1929 photograph. Shown in the second row, other members of the wedding party are, from left to right, Alexander Koziatek, Rose Senk, and ? Karnasiewicz.

20

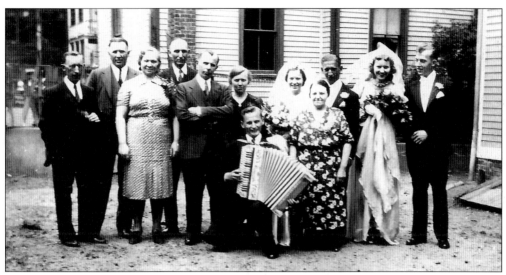

An accordionist, known only as "John," plays at an impromptu backyard post-wedding party at 95 Grove Street in honor of the May 14, 1938 nuptials of Aniela Czaplicki and Joseph Kaczynski. The other people pictured in this image are, from left to right, the following: Konstanty Kaczynski, Florian Lojewski, Leokadia Lojewski, Piotr Mudzinski, Albert Sadowski, Anastazja Mudzinski, Aniela Czaplicka (bride), Weronika Sadowski, Joseph Kaczynski (groom), Sophie Mudzinski, and Edward Lipinski.

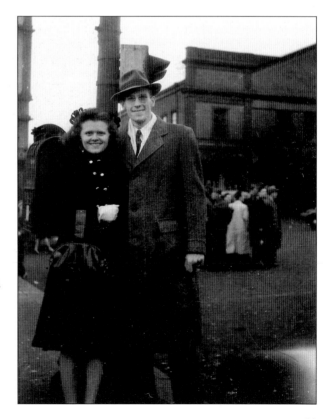

Joseph G. Maciora of New Britain and his bride, Mary Mik of Meriden, stand in front of the train station in Brooklyn, New York, shortly after their arrival. The newlyweds lived in New York while Joseph finished his schooling at Brooklyn Polytechnic Institute.

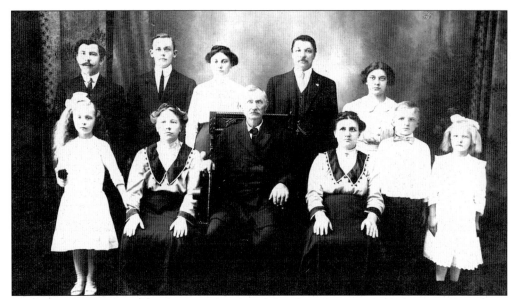

The family patriarch sits in the front center in this three-generation portrait made in 1913. Pictured in this image are, from left to right, the following: (first row) Pauline Kaczynski, Helena Pierzan Kaczynski, Jan Pierzan, Marianna Pierzan Kania, Walter Kania, and Mary Kania; (second row) Alexander Kaczynski, Ignacy Gnoza, Franciszka Pierzan Gnoza, Pawel Kania, and Bertha Kania. Jan Pierzan was the father of Helena Kaczynski and Maryanna Kania and was the uncle of Franciszka Gnoza.

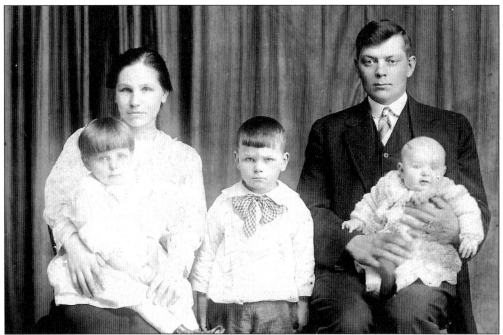

Young families formed the majority of New Britain's Polish community in the 1920s. Typifying the era is the Malodziejko family of Cleveland Street. In this 1920 portrait, Bronislawa Kryszczynska Malodziejko holds two-year-old daughter Regina, five-year-old John stands between his parents, and Jan Malodziejko holds infant son Kazimierz.

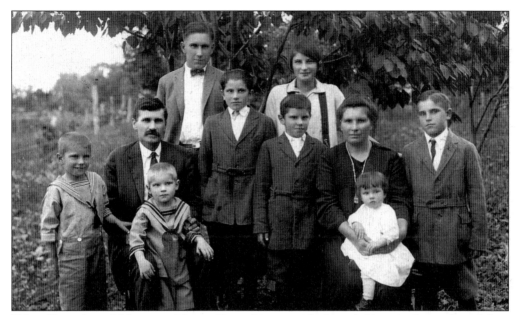

Hilary Kawecki and Maryanna Nastyn Kawecki pose with their children in the garden of their Alden Street home c. 1925. Pictured in this image are, from left to right, the following: (first row) Walter, Hilary (with son Peter between his knees), Hipolit, Tadeusz (also known as Leonard), Maryanna (holding daughter Izabela), and Ralph; (second row) Henry and Julia. Hilary Kawecki was a native of Ulatowo Adamy.

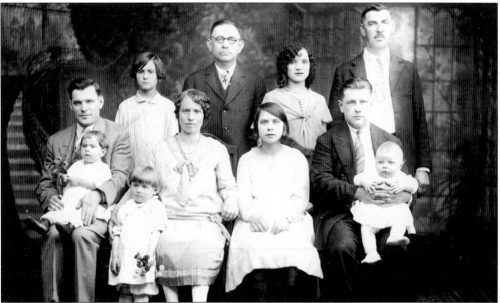

The Plewa, Palys, and Lukaszewicz families assemble in 1928 for a portrait precipitated by Jan Plewa's impending return to Poland. Pictured in this image are, from left to right, the following: (first row) Joseph Palys (holding daughter Lucy), Jean Palys, Mary Palys, Sophie Lukaszewski, and Frank Lukaszewski (holding son Edward); (second row) Helen Palys, Jan Plewa, Veronica Rogers, and Wladyslaw Lukaszewski. Jan Plewa was the father of Mary Palys, Sophie Lukaszewski, and Veronica Rogers.

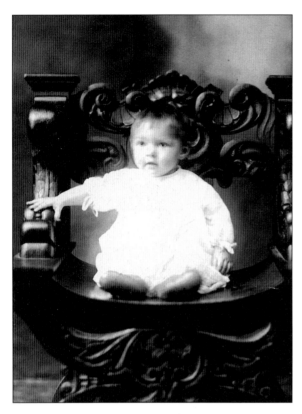

Terryville native Helen Struminski, daughter of Jan and Eleanora Lipowski Struminski, sits in a chair much bigger than she is. In 1920, when she was one year old, her family moved to New Britain. As an adult, she married Joseph S. Nadolny. Migration between Polish communities in the first decades of the 20th century was not unusual, as people relocated to find better jobs or to be closer to relatives.

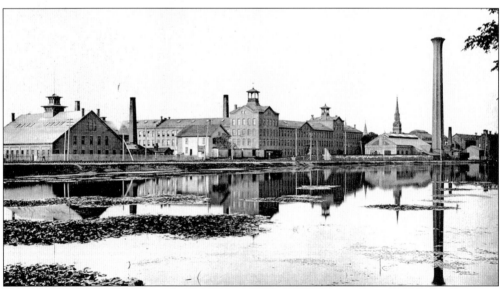

The waters of Lock Shop Pond, located at Myrtle and High Streets near downtown New Britain, were a familiar sight to workers reporting to the Russell and Erwin Manufacturing Company. The pond was filled in and the area was paved for parking in the 1950s. Today, the Thaddeus Kosciuszko Highway runs through here. The spire of the old St. Mary Church is visible to the left of Russell and Erwin's tallest smokestack.

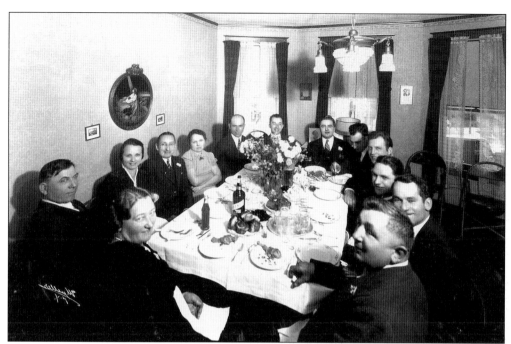

In this image, the family of Joseph Malinowski awaits their Thanksgiving turkey dinner in the dining room of their Silver Street home. Polish immigrants, while retaining their distinct customs and cultural celebrations, readily embraced American practices in their adopted homeland.

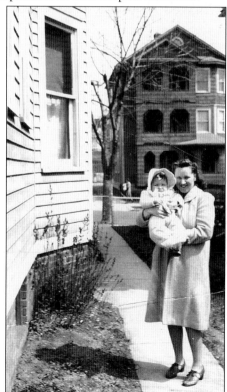

Helen Grabowski takes her year-old goddaughter, Lillian Sztaba, out for some fresh air near the family's Albany Avenue home. Two- and three-family homes were built in this area c. 1920 as the core Broad Street neighborhood became more densely settled.

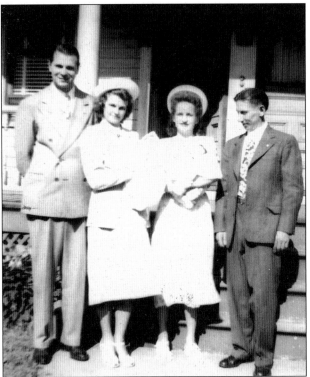

En route to Sacred Heart Church for a double baptism ceremony in 1948, two sets of godparents pose with their twin godsons on High Street. Seen in this image are, from left to right, the following: Edward Kostrzewa, Genevieve Kaczmarczyk (holding Thomas Plocharczyk), Celia Marszalek (holding Daniel Plocharczyk), and Walter Plocharczyk. The infants' parents were Joseph and Sophie Marszalek Plocharczyk of High Street.

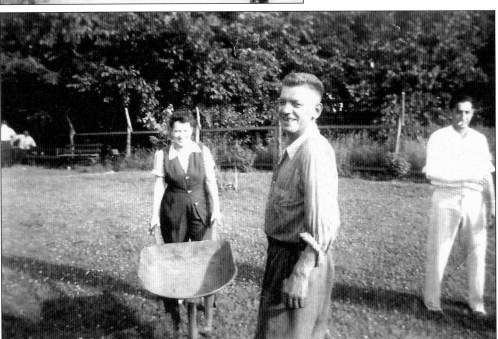

Jozef Bryzgiel (center) and his niece Leocadia tend the family "farm" on the corner of Broad and Bond Streets in 1943 as an unidentified man looks on. Many families cultivated large flower and vegetable gardens, evidence of the Poles' centuries-long attachment to the land. In fact, the country's name, Polska, derives from the Polish word for field.

Stella Kita mows her grass at 150 Gold Street with an old-fashioned push lawnmower powered by nothing more than muscle and sweat. Neatly kept homes and yards characterized Polish New Britain. Kita was born in the Ostroleka area of Poland. She came to the United States in 1929 and worked in restaurants owned by her husband, Joseph.

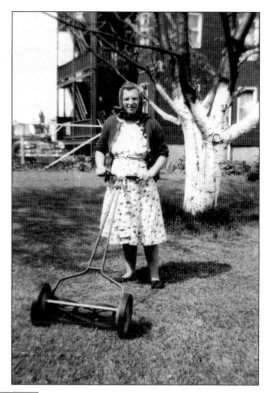

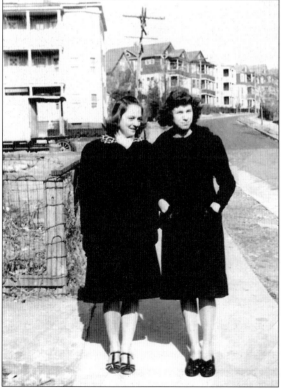

Helen Bryzgiel (left) and Florence Dumin (right) stand at Smith and Broad Streets in the late 1930s. Partially visible on Broad Street in front of the closest house is an ice wagon, a familiar neighborhood sight in an era when iceboxes, the precursors of refrigerators, were standard kitchen appliances.
A row of relatively new three-family homes on upper Smith Street fills the background.

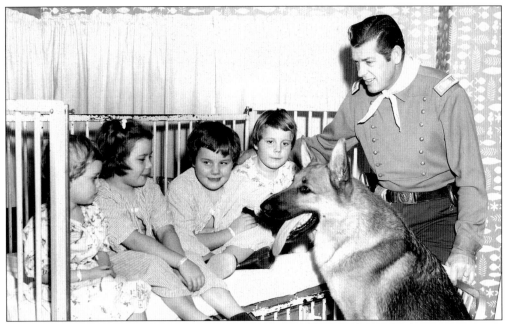

Recuperating from tonsillectomies at New Britain General Hospital in 1956, four sisters receive a visit from two Hollywood stars: actor James Brown, who played Lt. Rip Masters in television's *Adventures of Rin Tin Tin*, and "Rinty" himself. The girls are, from left to right, Barbara, Marsha, Margaret, and Patricia Neumeister, the daughters of Fred and Veronica Rutkowski Neumeister.

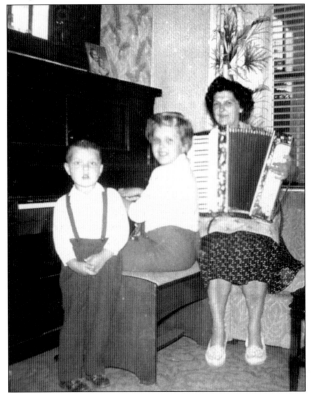

John Kusinski listens while his sister Christine plays the piano and his mother, Helen Ziolkowski Kusinski, accompanies her on the accordion in their Clinton Street home. Music became a lifelong passion for John; as an adult, he was a professor of music at the University of Hawaii.

Constance Malodziejko and Stanislaw Ochnio were wed at Sacred Heart Church in 1956. Malodziejko, a New Britain native and longtime office manager for the State Council of Machinists, met her future husband shortly after he arrived in New Britain from Europe. During World War II, Ochnio was taken from his native Siedlanow, Poland, and sent by the Nazis to forced labor in a pharmaceutical plant in Germany. He came to the United States after a stint in the coal mines near Charleroi, Belgium.

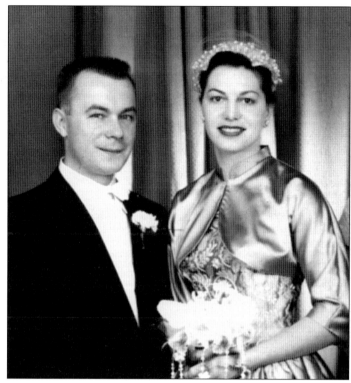

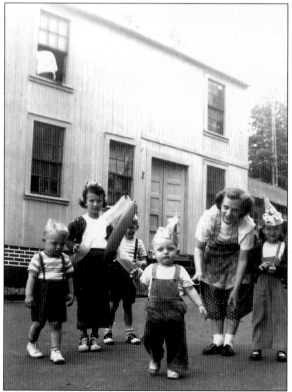

The Wrobel and Mehan families gather at their Beatty Street home to celebrate John Mehan's birthday, complete with balloons and party hats. Pictured in this image are, from left to right, Thomas Mehan, Ann Wrobel, Joseph Mehan, John Wrobel, Theresa Wrobel, and Leona Wrobel. Decades earlier, a portion of the home was used for Piotr Wrobel's business, which is believed to have been the first Polish-owned soda bottling works in the city.

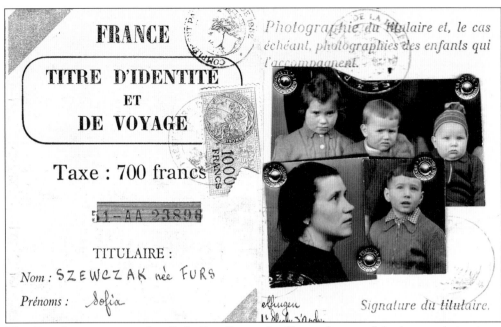

FRANCE

TITRE D'IDENTITÉ
ET
DE VOYAGE

Taxe : 700 francs

51 - AA 23898

TITULAIRE :

Nom : SZEWCZAK née FURS

Prénoms : Sofia

Photographie du titulaire et, le cas
échéant, photographies des enfants qui
l'accompagnent.

Signature du titulaire.

This French passport issued to Zofia Furs Szewczak offers a glimpse of the long and circuitous route she took to New Britain. Born in Lozowiki, Poland, she was taken by the Nazis in World War II to a German forced labor camp, where she worked as a submarine welder. After the camp's liberation by American troops, she joined her husband, Edmund, at St. Chely d'Apcher, France. Edmund later traveled to New Britain, and in 1954 he was joined by Zofia and their four children. This passport bears their photographs; shown in the image are, from left to right, the following: (top row), Irena, Anna, and Richard; (bottom row) Zofia and Tadeusz.

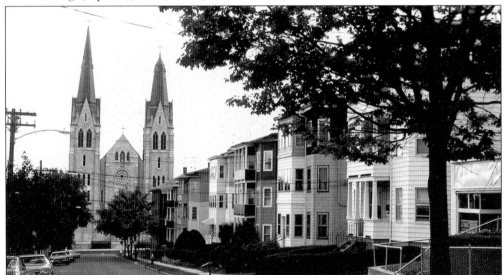

The landmark Sacred Heart Church dominates the intersection of Horace and Broad Streets, shown here c. 1960. Horace Street's three- and six-family houses illustrate the comfortable but practical homes the Poles built in the early decades of the 20th century. The development of Horace, Gold, Silver, Lyman, and other neighborhood streets began around 1910, claiming the fields that had long covered the area.

Three
KEEPING THE FAITH

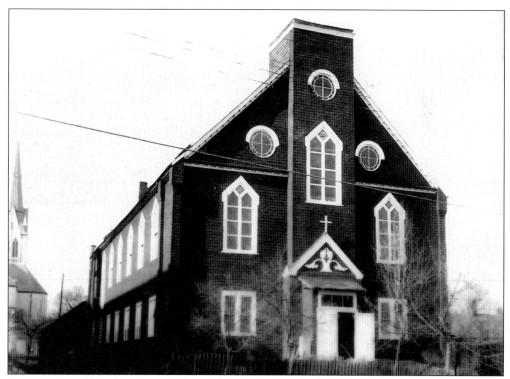

Construction of the first Sacred Heart Church, located on Orange Street, began in the summer of 1896 and was completed that October. The basement contained schoolrooms and the rectory. After the new church was built in 1904, the old wooden church served as the parish school.

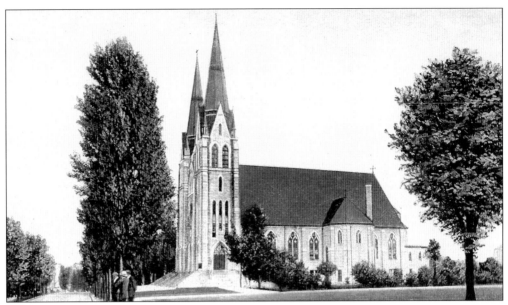

Begun in 1902, Sacred Heart Church on Broad Street was completed two years later. The Gothic-style, white-sand-marble exterior is 160 feet long. It was graced by two 178-foot-high spires; the top of one of the spires was later damaged by lightning, and it was shortened as a result. The interior of the church, which seats 1,500, is built of blue stone; it has five altars, two naves, and a choir loft.

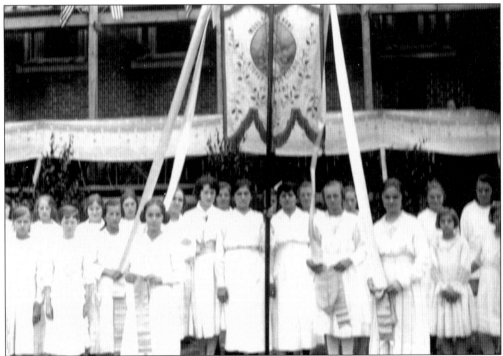

Members of the Sodality of Mary assemble under their society's banner in 1910. Founded in 1897, the society was one of the first religious organizations in the parish. Its members were dedicated to praying, performing works of charity, and assisting in parish functions.

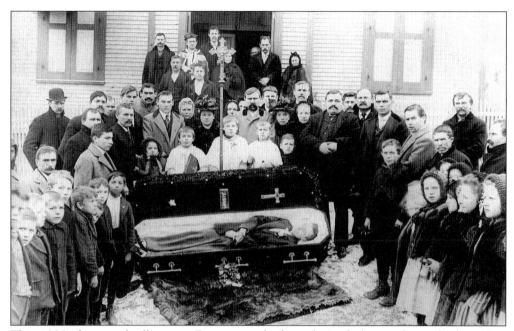

This 1906 photograph illustrates European-style funeral rituals being observed when New Britain's Polonia was in its formative stage. Mourners dressed in dark clothing surround a fully open coffin, posing for a solemn photograph that will commemorate the occasion. The casket, more ornate than a simple pine box, suggests the deceased was a man of some means.

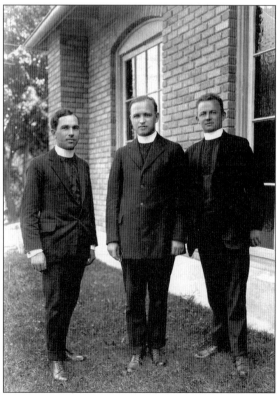

Two brothers from New Britain, Rev. Paul Bartlewski (left) and Rev. George Bartlewski (center), stand with a fellow priest in the yard of St. Stanislaus Church in Bristol. George, the founder of the Bristol parish, was the first native son of Sacred Heart Parish to be ordained to the priesthood in 1915; he became a monsignor in 1963. Paul was ordained in 1924 and served at St. Adalbert's Church in Thompsonville for more than 30 years. The priests were the sons of Kajetan and Justyna Nastyn Bartlewski.

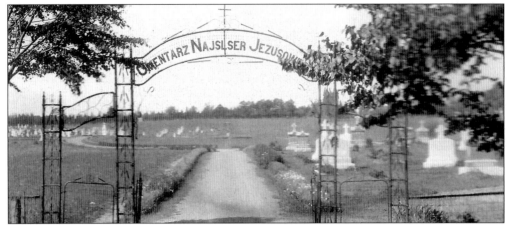

The wrought-iron gates that once marked the Burritt Street entrance to Sacred Heart Cemetery are long gone. This 1920s photograph shows that the first burials took place on the front right and upper left quadrants of the graveyard. Founded in 1912, Sacred Heart is the largest Polish parish cemetery in New England; there are more than 10,000 interments recorded.

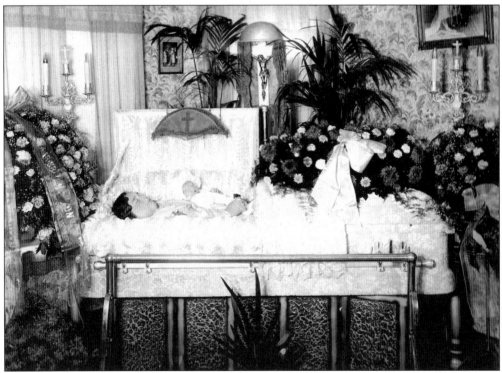

Boleslawa Zach Cyrulik and her infant daughter, Anna, lie in state in the parlor of their Clinton Street home in 1932. Home wakes and all-night vigils were common in New Britain until the 1940s, when the conveniences offered by funeral homes gradually replaced ceremonies in the decedents' homes.

On *Dzien Zaduszny* (All Souls' Day) each November, the Polish community honors the memory of the dead with votive lights and ornate floral displays at Sacred Heart Cemetery. On November 2, the cemetery is a sea of scarlet lights, continuing a centuries-old Polish tradition.

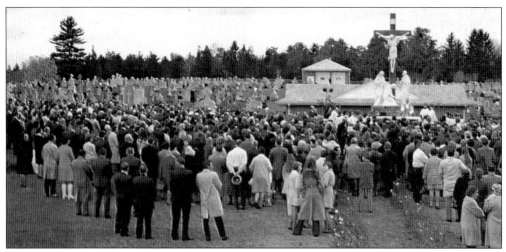

The devotion of the community to the memory of deceased family members is evident in the large crowds that congregate yearly for the *Dzien Zaduszny* open-air Mass at Sacred Heart Cemetery. Unique among the region's Polish cemeteries, it is the sole burial ground where All Souls' Day is observed with such ceremony.

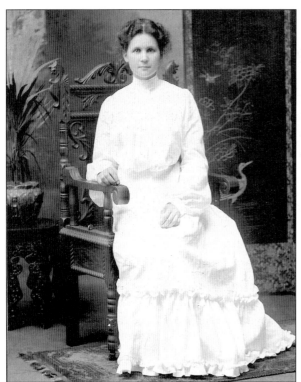

Zofia Mysliwiec, born in Kamienna Nowa, was the daughter of Franciszek and Elzbieta Skoczko Mysliwiec. She posed for this portrait prior to entering the convent. In 1904, Reverend Bojnowski founded the Daughters of Mary of the Immaculate Conception, which was composed of nuns initially dedicated to caring for orphans. As Sister Mary Germana, Mysliwiec became one of the order's founders. The others were Sister Agnieszka, born Barbara Waltosz; Sister Lucja, born Wiktoria Bobrowska; and Sister Koleta, born Antonina Bernard.

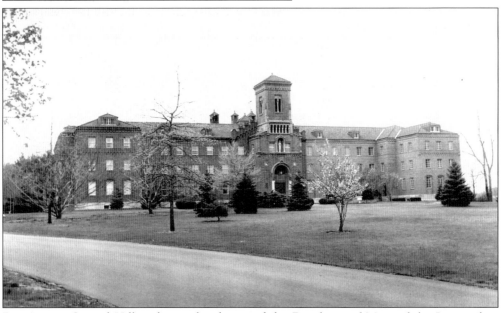

Dominating Osgood Hill is the mother house of the Daughters of Mary of the Immaculate Conception. It was built in 1937 to replace the original, much smaller convent. At its peak, the order numbered about 175 sisters. They staffed schools, hospitals, and homes in New York, New Jersey, and Massachusetts, as well as in Connecticut. A landmark in New Britain, the mother house is situated on spacious grounds that include a cemetery where deceased members of the congregation rest.

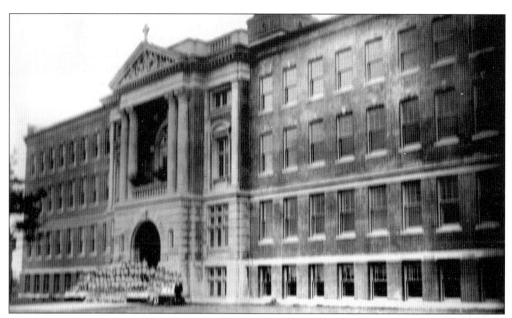

Rising high atop Convent Heights, the Orphanage of Our Lady of Rozanystok was constructed in a little over a year. Ten thousand people, including a wide array of church and political leaders, attended its 1923 dedication. The vast grounds were the site of a full-fledged farm tended by the sisters and orphans. By 1929, about 500 children from the northeastern United States and Canada had been placed at the orphanage. Not all the children were parentless. Some single parents, mainly those who had been widowed, left their children there temporarily in times of economic distress.

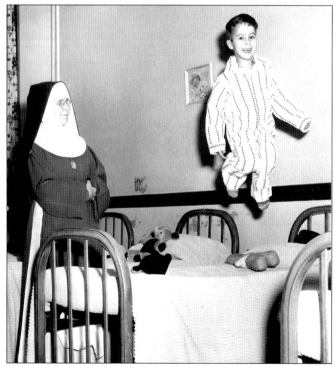

An unidentified boy grins as he jumps on his bed in the dormitory at the Polish orphanage; one of the sisters looks on. Schoolwork and farm chores may have filled much of the day, but there was always time for simple fun. The orphanage closed in June 1970. Meeting the needs of changing times, the facility took on a new purpose as Our Lady of Rose Hill Day Care Center.

37

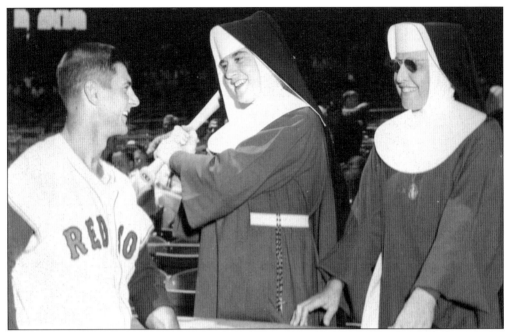

Red Sox left fielder Carl Yastrzemski, a descendant of Polish immigrants who settled in eastern Long Island, smiles as Sister Mark grips his bat during Nuns Day at Fenway Park. Sporting sunglasses at right is Sister Honorata. Boston Archbishop Richard Cushing sponsored this Boston treat in the early 1960s.

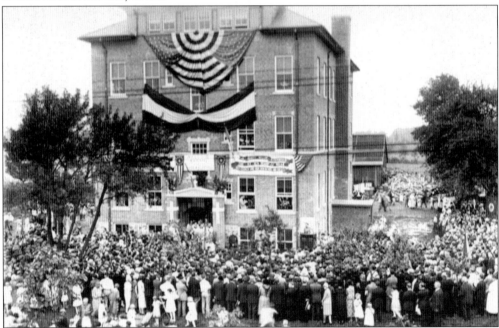

A large crowd gathers to greet Roman Catholic bishop John Nilan of Hartford for the dedication services of St. Lucian's Home for the aged on Burritt Street. The construction crew included a corps of volunteers mustered by the indefatigable Reverend Bojnowski. Constructed in 1925, the home was the last of the pastor's major building projects.

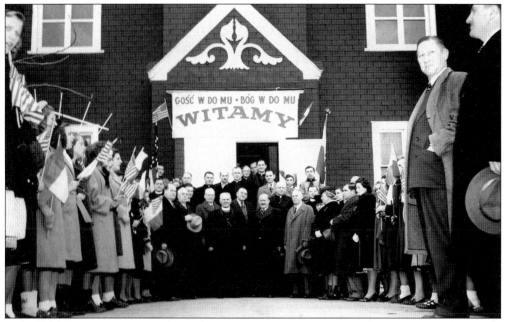

Msgr. Lucjan Bojnowski and Stanislaw Mikolajczyk, the premier of Poland's government in exile in London during World War II, stand front and center below a *Witamy* banner welcoming the statesman to New Britain *c.* 1947. "*Gosc w domu, Bog w domu*" is a Polish saying that essentially means "A guest in the house equals God in the house."

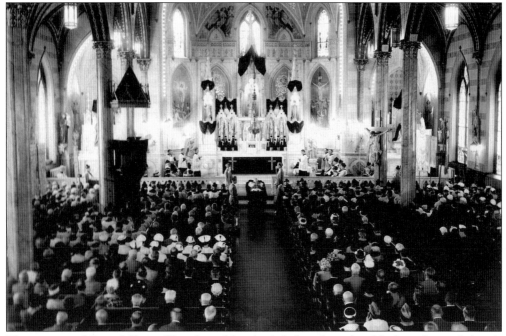

The interior of Sacred Heart Church is ablaze with lights, draped in black, and crowded with mourners for the funeral Mass of Msgr. Lucjan Bojnowski in July 1960. In a career that spanned more than half a century, Bojnowski built the church and ministered to thousands of New Britain's Poles from its pulpit.

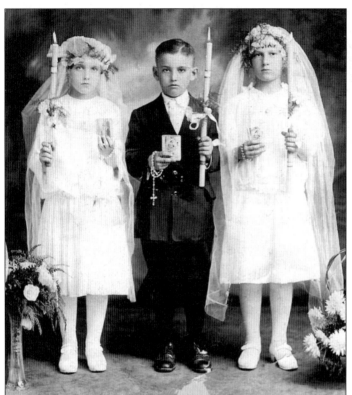

Veronica Mierzejewski, her brother, Stanislaus Mierzejewski, and their cousin, Leocadia Bryzgiel, display their First Communion candles after an October 1924 service. White dresses and veils for girls and dark suits for boys were the standard attire for this rite of passage in Catholic children's lives.

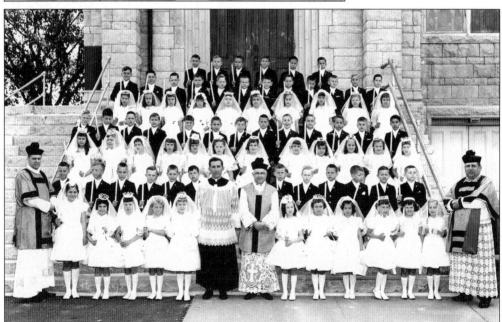

As the post–World War II baby boom generation grew in the 1950s and 1960s, communion classes grew large, as evidenced by this 1965 group at Sacred Heart Church. Standing among the children in the first row are four priests. They are, from left to right, Rev. George Zieziulewicz, Rev. Stanislaus Kozakiewicz, Pastor John Balasa, and Rev. Theodore Gubala.

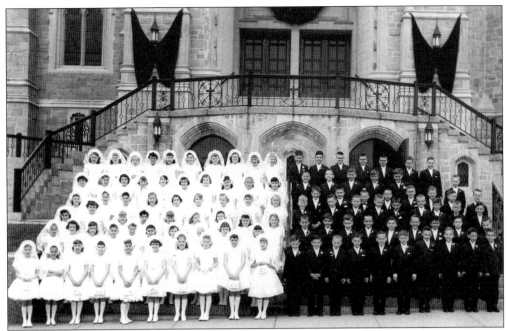

The 1961 First Communion class poses on the steps of Holy Cross Church. Behind them, black shrouds of mourning mark the passing of Rev. Stefan Bartkowski. The first pastor of Holy Cross, Bartkowski served the parish for more than 30 years and supervised the construction of the new church and parish school.

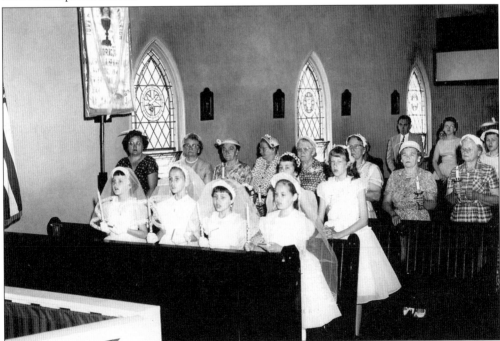

Girls of the Polish National Catholic Church of the Transfiguration of Our Lord stand with their First Communion sponsors in this c. 1960 photograph, taken in the Concord Street church. Transfiguration was the smallest of New Britain's three Polish parishes.

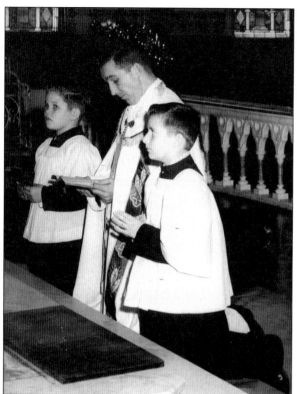

Rev. Stanislaus Kozakiewicz kneels in prayer with two of the many altar boys who have served Sacred Heart Church over the decades. Daniel Plocharczyk (left) went on to join the priesthood and became the pastor of his native parish in 2003. At right is Michael Majewski.

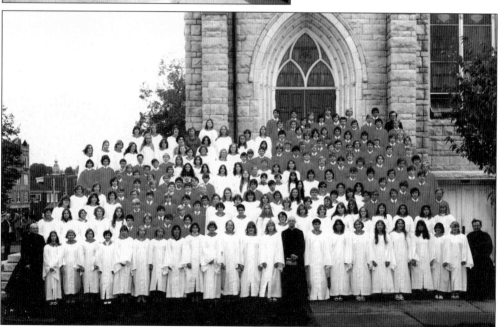

Dressed in sacramental robes, white for girls and red for boys, a group of approximately 150 young people fill the stairway at Sacred Heart Church upon making their confirmation on October 2, 1977. Confirmation is administered to baptized Catholics with the intent of strengthening them as followers of Jesus Christ.

This January 1927 handbill announces a meeting at the Rialto Theatre on Broad Street to form a second Polish Roman Catholic parish in New Britain. Overcrowding at Sacred Heart, rapid neighborhood development in the Farmington Avenue area, and the assimilative tendencies of the younger American-born generation all contributed to the formation of Holy Cross Parish. At its beginnings, Holy Cross comprised 3,000 parishioners.

It was to be the last Polish Roman Catholic parish founded in Connecticut.

Ważne Posiedzenie!

Polonji New Britainskiej

odbędzie się

w Poniedziałek wieczorem

o godzinie 7:30

dnia 10go Stycznia, 1927

W SALI RIALTO

[Nad Nowym Teatrem]

przy rogu Broad i Washington ul.

w Sprawie

Organizacji Drugiej Parafji Polskiej Rzymsko-Katolickiej.

Wszyscy Proszeni!

Młodzi i Starzy

WSTĘP WOLNY!

Holy Cross Parish constructed the first of its two churches on Farmington Avenue in 1928. A relatively small wooden building, it functioned as a church for just a few years before it took on a second life as the parish hall.

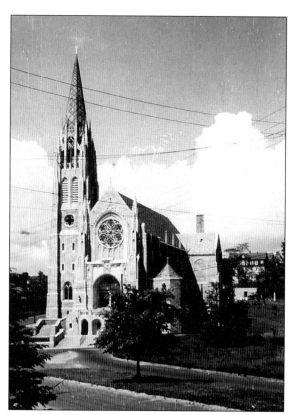

Holy Cross began plans to erect a larger, more beautiful church at Farmington Avenue and Biruta Street in 1933. By 1935, the lower church was ready for use. The dedication of the upper church took place in September 1942, with more than 40 priests and numerous religious and secular societies taking part.

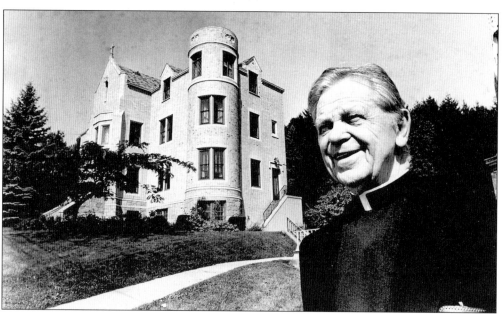

Msgr. John Wodarski stands on Biruta Street in front of the rectory of Holy Cross Parish, where he began his pastorate in June 1961. The rectory, modeled after a building in Torun, Poland, served as the priest's residence until his retirement in 1992. A military chaplain decorated with the Bronze Star for bravery in World War II, Wodarski was a strong supporter of Polish cultural activities.

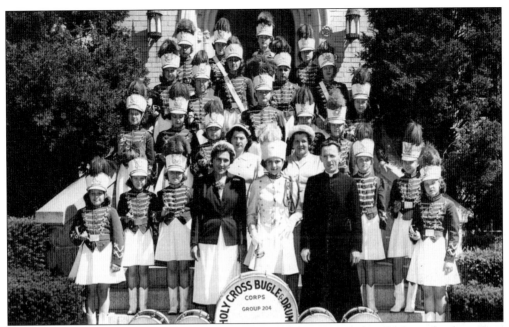

Members of the 1946 championship Holy Cross Bugle Corps stand with their chaplain, Rev. Benedict Sutula, on the steps of the Holy Cross rectory. According to the corps roster, members were F. Gorski, L. Baclawski, M. Baclawski, J. Bain, M. Baranowski, B. Boyle, C. Boyle, S. D'Alessandro, C. Dobrowolski, D. Dobrowolski, M. Drake, B. Dziezyk, E. Flis, T. Grabowski, P. Keyko, I. Klukowski, P. Kobylarz, P. Kolodziej, S. Konefal, L. Kuszaj, L. Labieniec, M. Lech, P. Lech, V. Lemanski, P. Moorehead, B. Napieracz, S. Pierce, M. Piontkowski, B. Potkay, A. Rutkowski, M. Skurzewski, P. Smulski, B. Tooker, B. Uryga, I. Wieczorek, E. Wilk, C. Wysocki, ? Dobrowolski, M. Kowalski, M. Nowinski, L. Kuszaj, and S. Tooker.

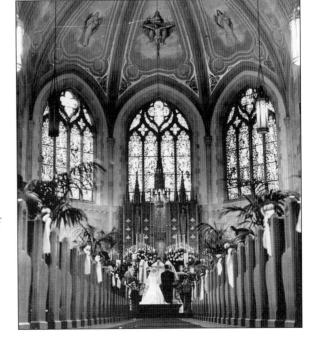

Henry J. Teklinski of Derby Street and Carolyn F. Leganza of Alexander Road kneel at the altar of Holy Cross Church on their wedding day in 1950. Rev. Benedict Sutula officiated at the October 14 ceremony. The decorated pews and intricate stained glass windows accentuate the church's elaborate French Gothic–style architecture.

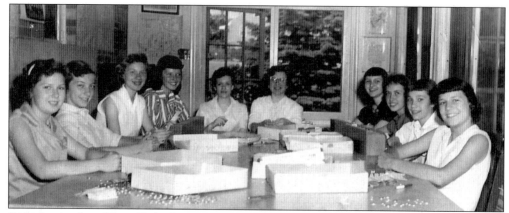

Seated around a table at Holy Cross rectory in 1959, volunteers help count the weekly Sunday offering. Pictured in this image are, from left to right, Arlene Gawelek, Elizabeth Grzewinski, Kathy Borowski, Diane Tuszkowski, Andrea Szetela, Patricia Petrisko, Barbara Nowobilski, Judy Gutowski, Kathleen Bialek, and Karen Kozlowski.

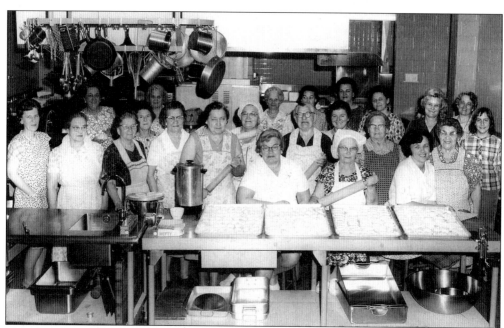

Marathon pierogi-making sessions are a familiar June activity for the women of Holy Cross Church as they prepare for the parish's annual fund-raising bazaar. In a typical year, the dedicated group produces upwards of 15,000 special-recipe pierogi. They measure and mix ingredients, roll and shape the dough, add varied fillings, pinch seams, and finally cook the pierogi. In 1967, the women pictured here made 15,500 pierogi from scratch.

Members of the Holy Cross Ladies Guild gather at the rectory to plan the organization's golden jubilee. Pictured are, from left to right, the following: (first row) Jean Higgins, Katherine Wasel, Helen Marinelli, Lucy Wilk, Mary Karwoski, Hedy Tyburski, and Wanda Dabrowski; (second row) Rose Marut, Florence Maikowski, Shirley Gurski, Lucy Wisniewski, Helen Lewandowski, Ceil Staskiewicz, Laura Tyburski, Natalie Liss, and Elsie Dombrowik.

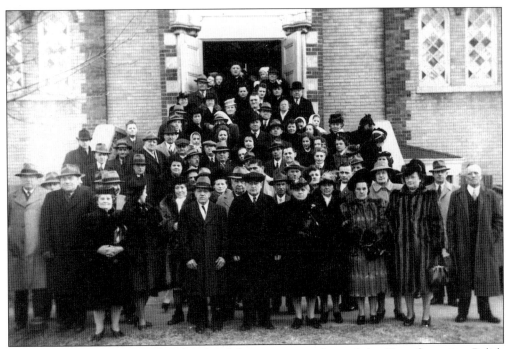

Prior to the construction of a church of their own, members of the Transfiguration Polish National Catholic parish worshipped at St. Stephen's Armenian Church on Tremont Street. They are shown here with their pastor, Rev. Zygmunt Szczepkowski.

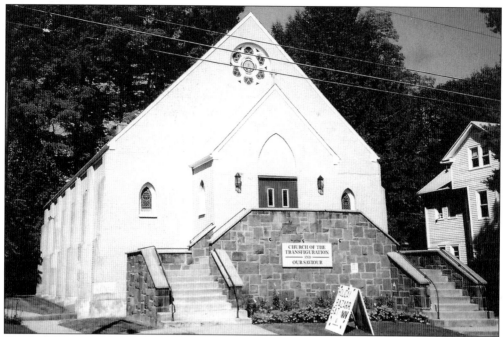

The Polish National Catholic Church of the Transfiguration of Our Lord purchased land for a parish church on Concord Street in 1943. Construction, supervised by building committee chairman Aleksander Woroniecki, was completed in 1951. The church was dedicated that June during the pastorate of Rev. Jan Gogolski.

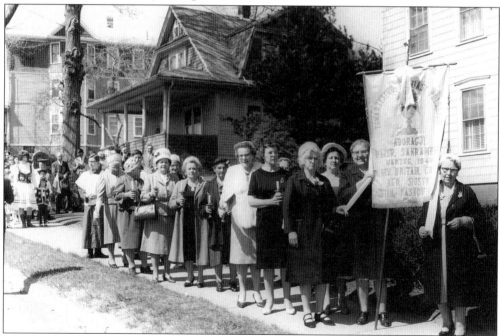

Members of the Adoration of the Blessed Sacrament Society march in procession down Concord Street to celebrate the 25th anniversary of Transfiguration Parish in 1967. The women's association was founded in March 1948.

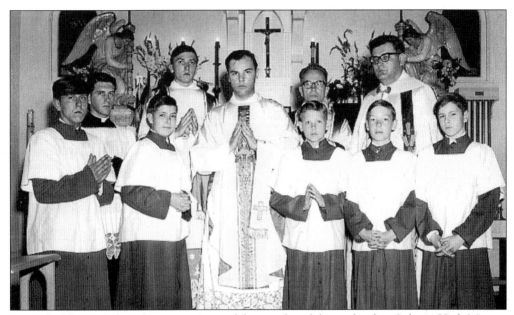

Rev. Thaddeus Dymkowski, a native son of the parish, celebrates his first Solemn High Mass at Transfiguration PNC Church. Seen here are, from left to right, the following: (first row) altar boys John Rosol and Michaek Golan, Rev. Thaddeus Dymkowski, and altar boys Richard Michalak, Eugene Gaj, and Walter Motulski; (second row) clerics A. J. Kargul and Stanley Loncola, Transfiguration's pastor Rev. Valentine Grabek, and Rev. Zygmunt Wojtowicz.

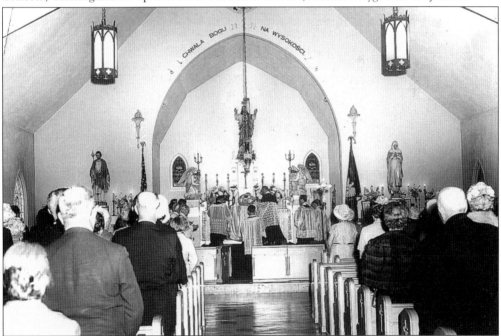

Parishioners fill the pews for a Mass celebrating Transfiguration's 25th anniversary in 1967. *Chwala Bogu na Wysokosci* (glory to God in the highest) is inscribed in the arch above the altar. Over the years, the parish sponsored a number of cultural and religious organizations, including the Blessed Sacrament, Maria Konopnicka, and Joseph Pilsudski societies, and a parent-teacher association.

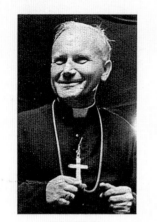

JEGO EMINENCJA
KAROL KARDYNAŁ WOJTYŁA
ARCYBISKUP KRAKOWSKI

PRZYJĘCIE
w
NEW BRITAIN, CONNECTICUT
DNIA 18-go WRZEŚNIA 1969

2:00 P.M. OBIAD — Biskupi i Księża
4:00 P.M. PACIERZ — Cmentarz Serca Jezusowego
5:30 P.M. MSZA ŚW. — Kościół Serca Jezusowego
7:30 P.M. PRZYJĘCIE — Holy Cross School

KIEROWNICTWO
Zjednoczenie Kapłanów Polskich w Connecticut
Kongres Polsko Amerykański w Connecticut

Prior to his elevation to the head of the Roman Catholic Church as Pope John Paul II, Cardinal Karol Wojtyla, Archbishop of Krakow, visited New Britain on September 18, 1969. Nearly all of Connecticut's clergy of Polish origin participated in a concelebrated Mass at Sacred Heart Church. The ceremony was followed by a reception and folk dance performance at Holy Cross School. The future pope also made a stop at Sacred Heart Cemetery.

Wearing his Haller Post veterans cap, Wlodzimierz Lausch prepares to kiss the ring of Pope John Paul II at the Vatican. With Lausch in the front row are other members of the New Britain veterans post delegation. Shown are, from left to right, Ernest Ganszyniec, Kazimierz Swiatocho, Lausch, and Helena Seweryniak.

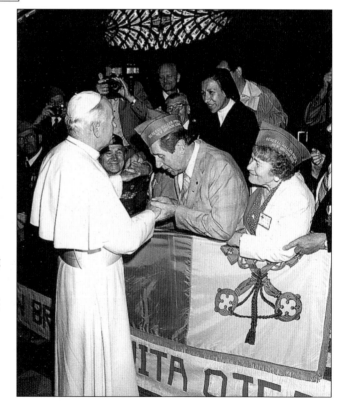

Four

ORGANIZATIONS

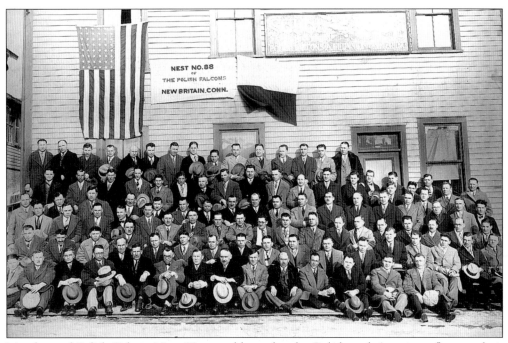

Members of Polish Falcon Nest 88 assemble under the Polish and American flags at their headquarters at Beaver and Broad Streets in the early 1920s. Falcon Nest 88, a chapter of a national fraternal organization dedicated to sport and physical culture, also took an active part in training candidates for the Polish Army in exile during World War I.

Pierwsze półrocze	Styczeń	Luty	Marzec	Kwiecień	Maj	Czerwiec	Suspendowany	Odsuspendowany	
~~Piotr Knap~~	156	156	1%	156	156				
1. Maryan Odachowski	37	37	37	37	37	37			37
2. Teodor Putata	37	37	37	37	37	37			37
236. ~~Leon Lemański~~	37	37	37				24 Czerwca		
3. Piotr Buczkowski	37	37	37	37	37	37			37
* ~~Antoni Karpiński~~	3						18 Marca		
4. Ignacy Niksa	37	37	37	37	37	37			37
5. Antoni Chlebowicz	37	37	37	37	37	37			37

This 1910 list enumerates some early members of Falcon Nest 88. Dues were a 50¢ introductory payment, followed by monthly fees of 25¢. By 1910, monthly dues had increased to 37¢. The New Britain Falcon Nest was established in 1907.

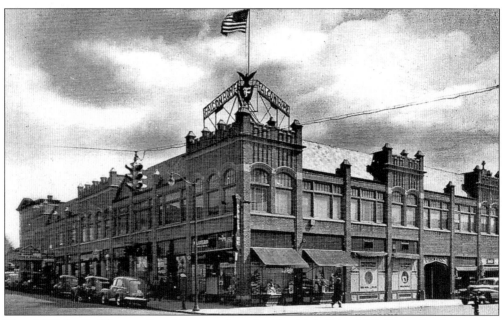

The old Rialto Building on Broad Street, adorned with a high-flying U.S. flag and a sign reading "Polish Home," occupies most of the block between Beaver and Washington Streets. It became the Falcons' permanent home in 1934. The building's upper story contains the nest's administrative offices, a bar, halls for meetings and dances, and the old sports teams' locker rooms.

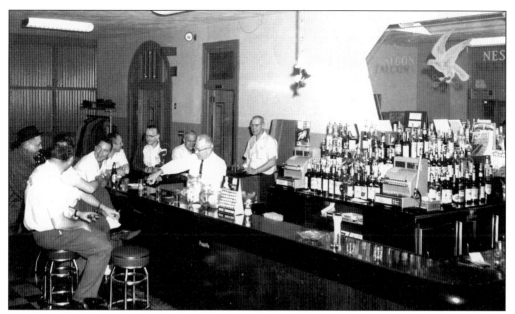

Members of Falcon Nest 88 laugh and joke at the bar on the upper floor of their Broad Street headquarters. In addition to a wide array of beverages, members could avail themselves of snacks such as pickled eggs, pickles, nuts, and chocolate bars, as well as cigars. The hats piled on the coat rack at the rear left hearken back to an era when men commonly wore fedoras.

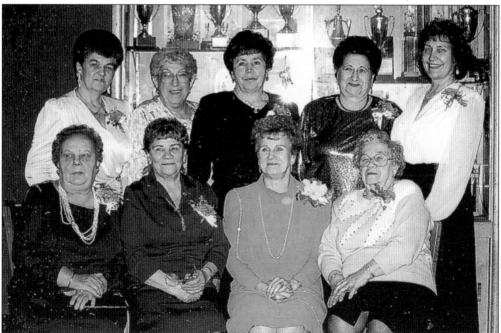

Officers of the Falcons' Ladies Auxiliary 811 pose before the trophy case in their Broad Street headquarters. Pictured are, from left to right, the following: (first row) Jadwiga Foley, Maria Stec, Zofia Gorska, and Cecylia Kowalewski; (second row) Romualda Kaczynska, Sally Budnik, Jadwiga Juskowiak, Eleanora Kolakowska, and Danuta Blaszko. The women's group, founded in 1924, initially assisted in the organization's athletic activities.

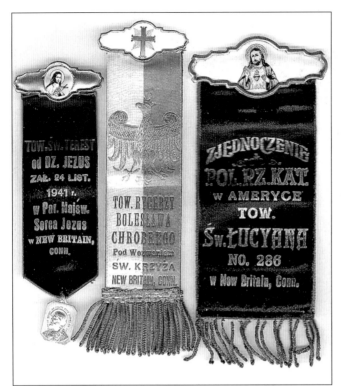

Displayed here are official ribbons of three local religious societies: St. Theresa of the Child Jesus, the Knights of Boleslaw the Brave, and St. Lucyan's Society of the Polish Roman Catholic Union of America. Members wore these ribbons for society functions and special occasions. The reverse side of each ribbon was colored black for use at members' funerals.

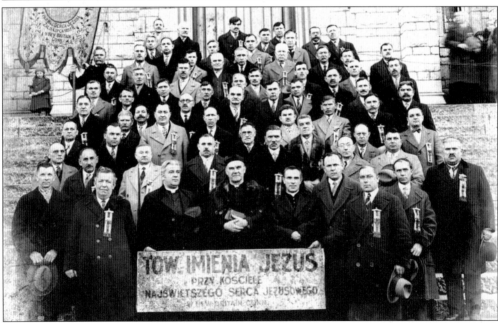

Members of the Holy Name Society of Sacred Heart Church, wearing the organization's ribbons, pose on the church steps with Reverend Bojnowski. Text on the processional flag indicates that the society was founded July 11, 1897, making it one of the parish's first organizations. The society's founding officers were Piotr Swider, Franciszek Grabowski, Kazimierz Werner, and Julian Maciora.

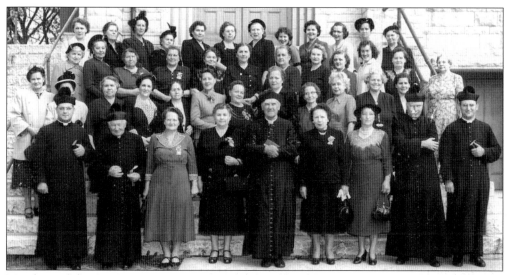

Members of the St. Agnes Society, a PRCUA branch at Sacred Heart Parish, pose before the church in 1955. The priests in the first row are, from left to right, Rev. Anthony Bish, Rev. Walenty Chrobok, Msgr. Lucjan Bojnowski, Rev. Anthony Smialowski, and Rev. Stephen Ptaszynski. Also identified in the first row is rectory housekeeper Zuzanna Siedzik (sixth from the left). In the fourth row are Helen Jurgilewicz (second from the left), Stefania Jurgilewicz Kania (third from the left), Rozalia Hojnowska (fifth from the left), Franciszka Wysocka (sixth from the left), and Teresa Maciag (ninth from the left).

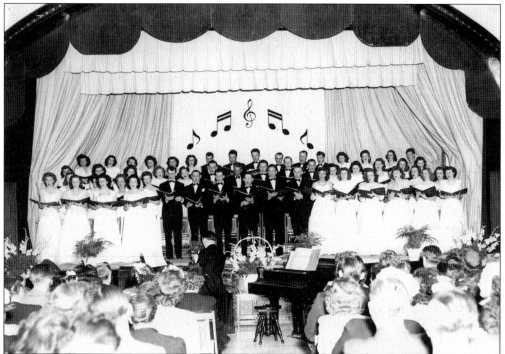

An audience listens to St. Cecilia's Choir perform in concert in the 1930s. The Holy Cross Parish choral group, founded in 1927, offered public performances in addition to singing at church services.

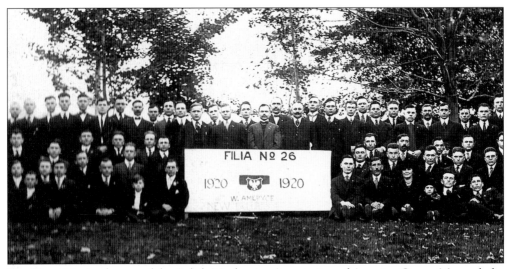

The New Britain chapter of the Polish Mechanics Association of America Group 36 stands for a photograph in an area park in 1920. Founded by Prof. Aleksander Gwiazdowski in Toledo, Ohio, the group promoted business enterprises, industrial development, and the acquisition of mechanical skills.

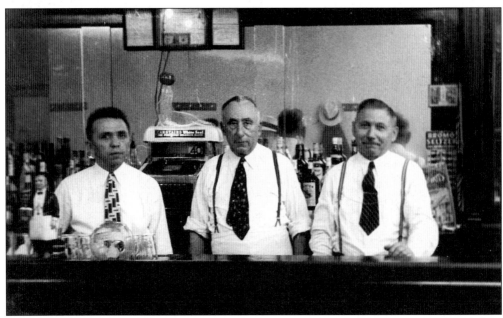

Staffing the bar at the Polish National United Societies Club on Beaver Street are, from left to right, ? Laskowski, ? Filipek, and ? Mazur. The club served as a place to socialize as well as a meeting venue for societies affiliated with Transfiguration Parish.

Unidentified members of Polish National Alliance (PNA) Lodge 478 (Youth of the White Eagle) pause in the doorway of their office at 229 Washington Street. The PNA, a national fraternal insurance benefit organization, at one time had three lodges in the city: Lodge 478, founded in June 1899; Lodge 2093 (Legion of a Free Poland), founded in September 1919; and Lodge 2612 (Queen Jadwiga), founded in December 1930. Lodge 478 eventually merged with Lodge 2093.

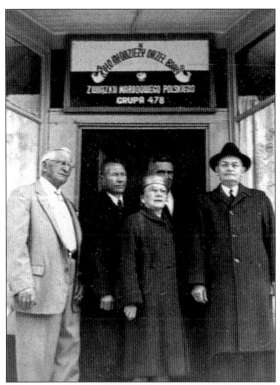

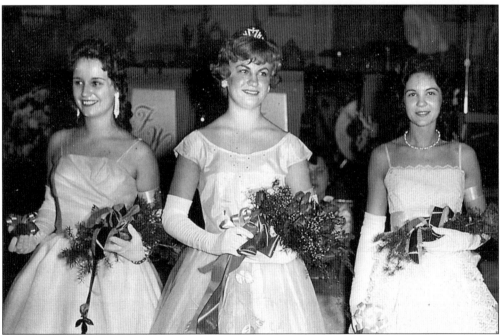

The winner and runners-up of the 1962 Miss PNA Council 58 pageant smile for the camera. Pictured in this image are, from left to right, Janice Pikul of Windsor Locks, winner Jane Prajsner of Thompsonville, and Lodge 478 representative Mary Niedzwiecki of New Britain. Local PNA groups also promoted Polish dancing and culture and held language classes.

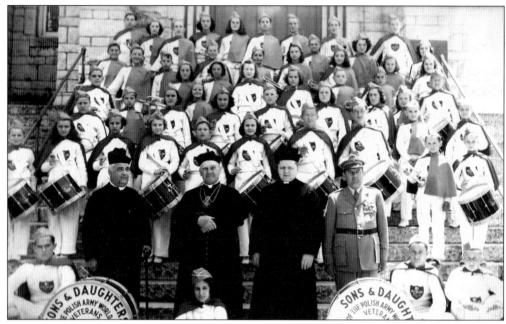

Dressed in their band uniforms, members of the Sons and Daughters of the Haller Post 111 Polish Army World War Veterans drum and bugle corps pose on the steps of Sacred Heart Church in the early 1950s. Many of the band members are the children of displaced persons who settled in New Britain after World War II.

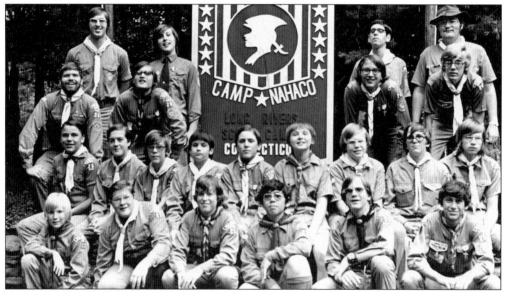

Boy Scouts from Holy Cross Parish spend a week at Camp Nahaco in Woodstock Valley. Pictured in this image are, from left to right, the following: (first row) Philip Panarella, Mark Franklin, Brian Hackney, David Dieli, Russell Sage, and Joseph Dabkowski; (second row) Roger Moss, Allen Franklin, David Sylvester, unidentified, David Niedzwiecki, unidentified, Mark Zawadzki, Daniel Zientarski, and Paul Dzilenski; (third row) David Dzilenski, Carl Dombrowik, Robert Dombrowik, and Brian Sylvester; (fourth row) Richard Krajewski, Daniel Dombrowik, Kenneth Bergenty, and Bruce Grzeszczyk.

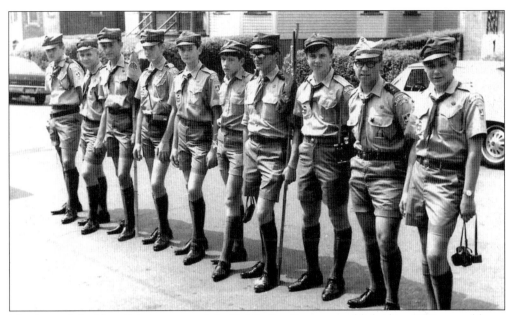

Members of the New Britain troop of the Polish Boy Scouts, established in 1957, assemble on Silver Street in anticipation of a 1969 World Jamboree in Monte Cassino, Italy. Shown are, from left to right, Czeslaw Dzierbunowicz, Ryszard Assarabowski, Boguslaw Dzierbunowicz, Jozef Badura, Roman Sypko, Jerzy Bielawski, Mieczyslaw Niziol, Marek Gawryszczuk, Zbigniew Chylinski, and Marek Wojcik.

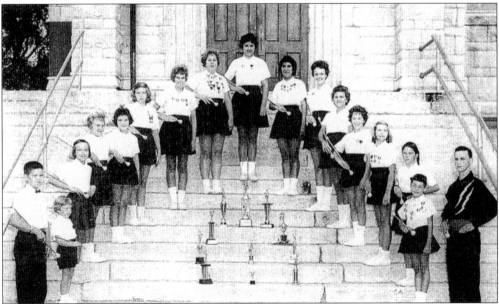

The Sergeant Sakowicz Post 1 Baton and Marching Unit displays its trophies in this 1961 photograph taken on the steps of Sacred Heart Church. Pictured are, from left to right, the following: David Dzilenski, Joan Lasota, Irene Flis, Marcia Kalinowski, Eileen Zajac, Linda Dzilenski, Aleta Timinski, Arlene Astoria, Janice Kowalczyk, Patricia Barr, Christine Zajac, Christine Anulewicz, Christine Lasota, Deborah Dzilenski, Lillian Petrewski, Deborah Fillion, and Dennis Shelto (instructor).

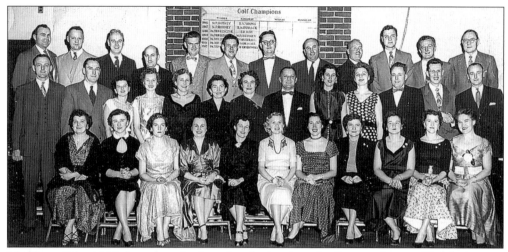

Members of the 44 Club, an organization of professionals and college graduates of Polish descent, attend a dinner dance at the Indian Hill Country Club in 1953. Pictured are, from left to right, the following: (first row): unidentified, Clare Mlynarski, three unidentified people, Frances Kraszewski, Jane Lexton, two unidentified people, Claire Granski, and Marie Gryboski; (second row) unidentified, Henry Mlynarski, Ceil Seremet, unidentified, Mary Bartlewski, Mary Zurek, Helen Milewski, Leo Milewski, unidentified, Lydia Syrocki, Judge Roman Lexton, Adam Syrocki, and unidentified; (third row) Dr. Joseph Granski, Alexander Parda, Dr. Henry Kraszewski, Dr. Peter Bartlewski, Dr. Anthony Yablonski, unidentified, attorney Stanley Zurek, unidentified, Boleslaus Gryboski, Alexander Kaczynski, John Seremet, and Dr. Joseph Mlynarski.

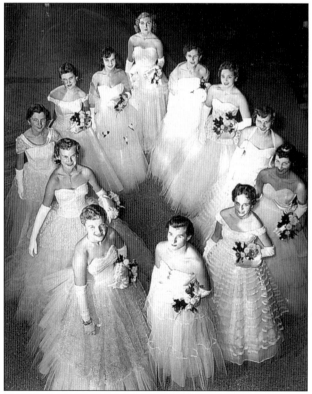

The Hartford-New Britain Chapter of the Polish Junior League and the Polish University Club of Connecticut cosponsored their first *Bal Menuet* at the Hotel Statler in Hartford in 1954. Debutantes pictured clockwise from the bottom left are D. Patricia Pac of New Britain, Elaine Dujack, Christine Maznicki, Germaine Kuklinski, Florence Kaminski, Edith Kapteina, Dorothy Bieszad, Helen Donovick, Marion Bielonko, Wanda Bieszad, Irene Zagaja, and Joan Studzinski.

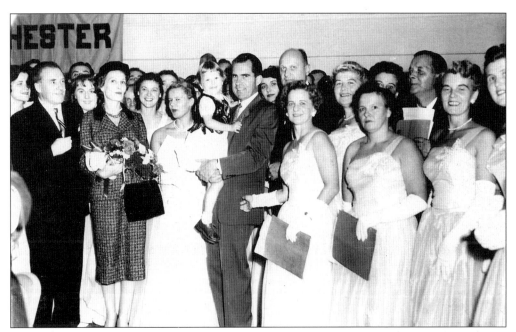

Vice president Richard Nixon and his wife, Patricia, pose with members of the Polonia-Paderewski Choir during a visit to New Britain in September 1959. Shown here in the first row are, from left to right, Prof. Antoni Kazmierczak, Pat Nixon, Alexandra Nowakowski, Richard Nixon, Emilia Koziol, unidentified, Irena Tarlowski, and Janina Motowidlo.

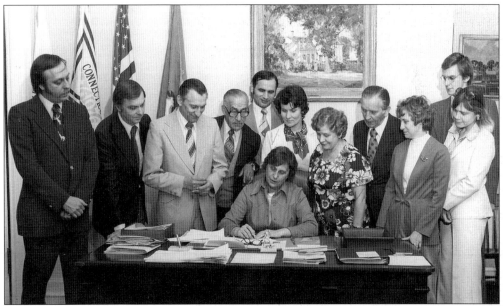

In the 1970s, Polish Americans in New Britain successfully petitioned Gov. Ella Grasso (seated) to name the New Britain portion of Route 72 the Tadeusz Kosciuszko Highway in honor of the Polish patriot and Revolutionary War hero. Committee members pictured are, from left to right, Lawrence Hermanowski, Henry Olszewski, Stanley Pac, Stanley Kaczynski, Dominik Swieszkowski, Bronislawa Swieszkowski, Maria Stec, Mieczyslaw Tarlowski, Ruth Olszewski, Stephen Hondzinski, and Irene Hermanowski.

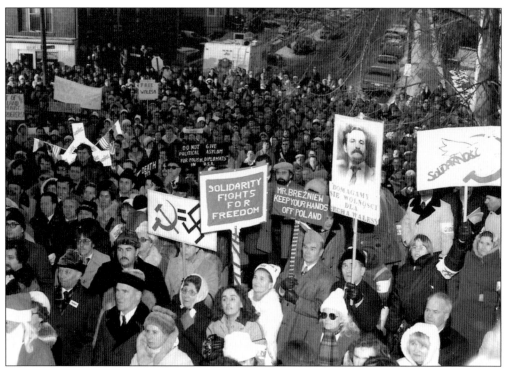

The declaration of martial law in Poland in December 1981 sparked immediate community reaction in New Britain. Signs supporting Lech Walesa and the Solidarity movement, along with anti-Soviet placards, express the crowd's feelings in this demonstration in front of Sacred Heart Church at Broad and Horace Streets.

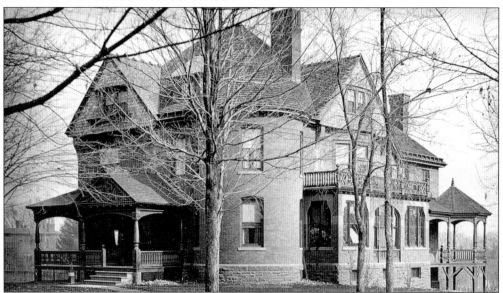

The stately Sloper mansion on Grove Hill served for many years as the home and office of Dr. Andrew Wesoly. After the physician's death, his family donated the building to the Polish American Foundation of Connecticut. The foundation comprises cultural groups dedicated to preserving and propagating all aspects of Poland's rich and varied cultural history.

Five
"Za Chlebem"

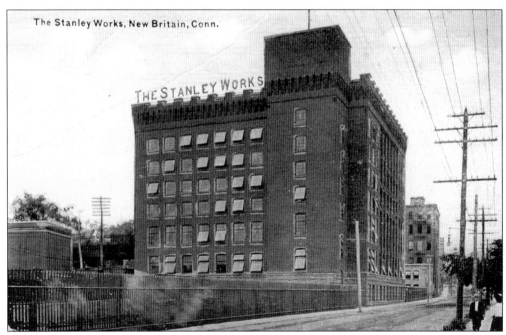

The Stanley Works, New Britain, Conn.

This Myrtle Street building is one of several that comprised the Stanley Works complex. The company started as a one-man bolt-making business in 1843. Known worldwide as a maker of builders' hardware, power tools, and hand tools, the corporation was a major reason why New Britain was justifiably called the Hardware City of the World.

CHEMICAL HAZARD CODE

		POLISH	ITALIAN	
◆	CORROSIVE IRRITANT SENSITIZER	WYZARCISTE DRAZNICISTE DRAZLIWISTE	CORROSIVO IRRITANTE SENSIBILIZZARE (RENDERE SENSITIVO)	GROUP A
◆	FLAMMABLE GENERATES PRESSURE	PLOMIENIACE WYSADZACE	FIAMMABILE GENERA PRESSIONE	GROUP B
◆	COMBINATION OF A & B	KOMBINACYA A & B	COMBINAZIONE DI A & B	GROUP C
☠	POISONOUS	JADOWITY	VELENOSO	GROUP D

THE STANLEY WORKS

Mindful of its employees' linguistic diversity, the Stanley Works posted signs in Italian and Polish as well as English to warn workers about corrosive and dangerous chemicals at use in the factory. Nearly two-thirds of Stanley's employees lived in multicultural New Britain.

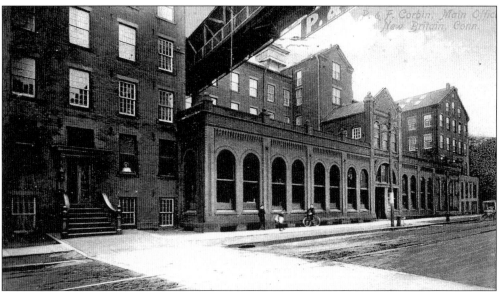

The main office of the P. & F. Corbin Company, located on Park Street, is shown on a postcard dated 1910. Organized in 1853, this Corbin company, one of three similarly named businesses operating in the city in that era, manufactured "everything in builders' hardware," according to an advertisement of that same year. Products included "the Corbin Liquid Door Check" and "artistic knobs, escutcheons and hardware trim for all kinds of doors and windows." Thousands of Polish Americans worked at the various Corbin plants.

Laundry hangs from the back porches of workers' houses on Orange Street, adjacent to the Fafnir Ball Bearing Company's main plant at Booth and Orange Streets. Fafnir, a relative latecomer to New Britain's industrial scene, was founded in 1911 and produced a complete line of all types and sizes of bearings.

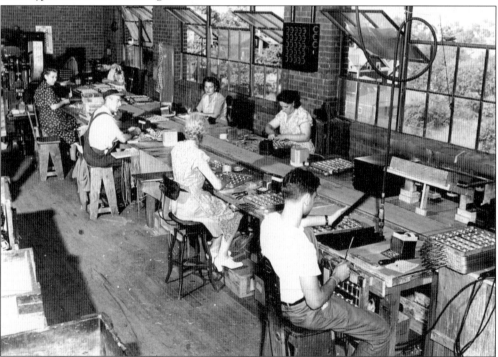

Employees at the Ellis Street plant of Landers, Frary & Clark work at their benches, assembling electrical appliances for the home. Originally a manufacturer of hat hooks, coat hooks, and cutlery, the company later produced Universal brand appliances that ranged from toasters and irons to vacuum cleaners and washing machines. The first food chopper manufactured in this country was patented at Landers in 1898.

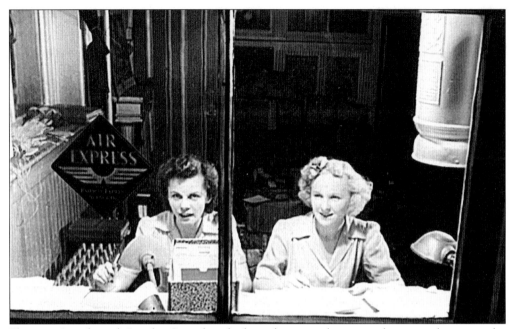

Florence Janick and Rosalie Starzyk calculate shipping charges and sort packages at the American Railway Express Company in 1943. The business was located in the railroad arcade. Photographer Gordon Parks made this image, one of a series he shot in New Britain while working for the United States Office of War Information. (Library of Congress.)

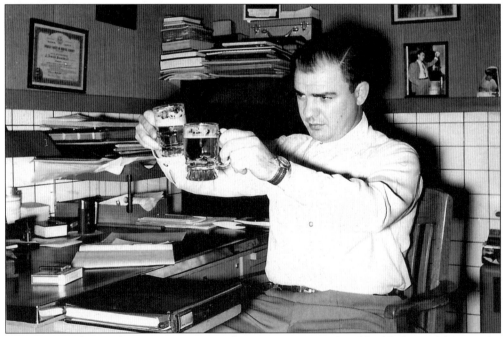

Brewmaster John Fred Neumeister Jr. visually examines a sample of freshly brewed beer at the Cremo Brewery Company. Descended from a long line of brewmasters, Neumeister put his skills to work for Cremo for almost a decade starting around 1946. He was born in Baltimore, Maryland, and married Veronica Rutkowski of New Britain.

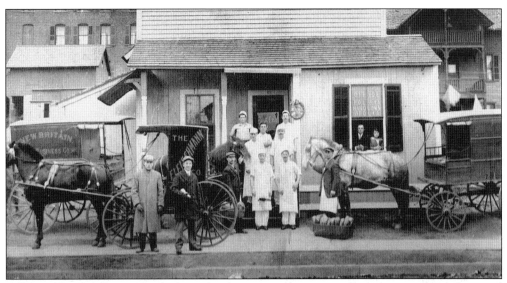

While most immigrants worked in the factories, others opened a variety of Polish-owned businesses to meet the community's daily needs. Here, horse-drawn carriages flank employees standing on the steps of the New Britain Polish Business Company, more commonly known as the Polish Bakery. One of the city's earliest Polish enterprises, the bakery was located on Broad Street between Smith and Cleveland Streets. It delivered breads and baked goods to homes and businesses citywide. Visible in the window at right is Boleslaw Mysliwiec, the business manager. Among the early employees were Feliks Talalaj, Jan Borkowski, and Veronica Kowalczyk.

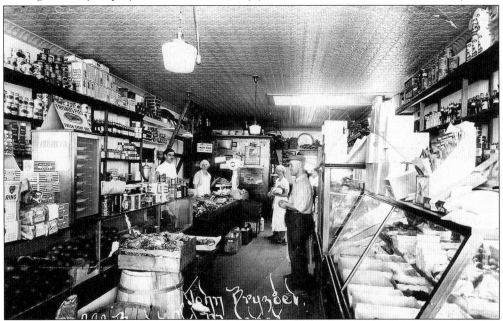

Jan Bryzgiel and his wife, Zofia, stand behind the counter of their family-operated grocery store and butcher shop, which they opened at 294 Broad Street in the 1920s. Perusing the array of baked goods and fresh vegetables are Zofia's cousin, Antoni Mierzejewski, and ? Krawiec. Markets such as this one dotted New Britain's Polish neighborhoods prior to the coming of the big supermarket chains.

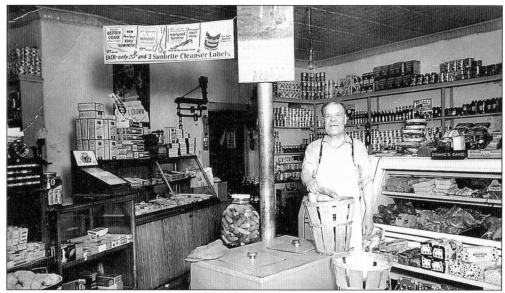

Wincenty Kryszczynski stands behind a gallon jar of homemade pickles and baskets of fresh vegetables, staples of his small market. Kryszczynski, a native of Chrzanowo, Lomza, came to New Britain in 1899. He left for St. Louis, where he worked in meat-packing plants, but returned after a short time to open his own business here.

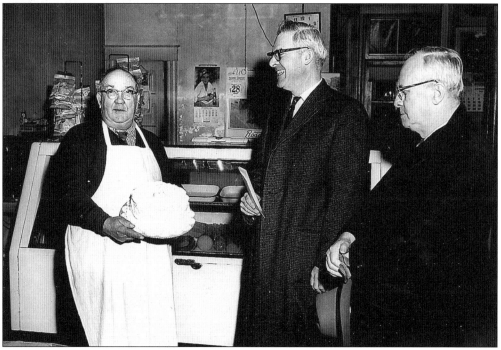

In his Miller Street market, Kazimierz Majewicz displays a freshly baked cake to James Dawson (center) and John L. Sullivan (right), both of whom served as mayor of New Britain. Majewicz served as alderman of the city's largely Polish fifth ward and was active in local and state politics. He opened his first market on Silver Street *c.* 1925 and relocated to High Street *c.* 1937. He was in business at 122 Miller Street from *c.* 1939 to 1963.

A 1930s-era black and red velvet sign highlighted by a white lily advertises Grove Street meat producer Martin Rosol's Easter kielbasa. Polish-style meat producers have always found steady customers in New Britain. Kielbasa is one of the traditional foods served at Easter meals.

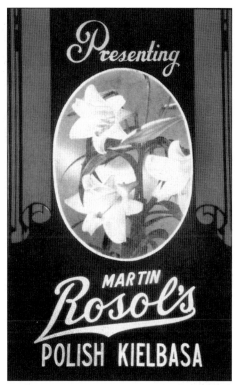

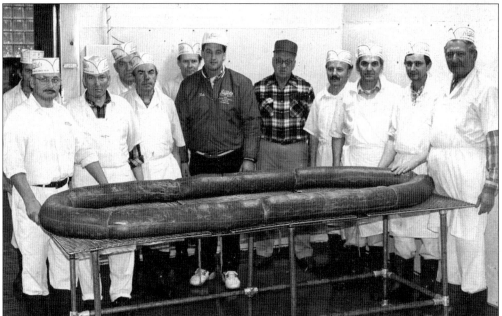

Enough kielbasa to feed an army, this 170-pound Polish sausage was a special order filled by Martin Rosol for the local First National Grocery Store. Company owners Robert and Eugene Rosol stand at the center of this image, surrounded by the crew that worked on the huge sausage. Big as it is, this kielbasa was not the crew's largest; they created a whopping 461-pound sausage in 1991.

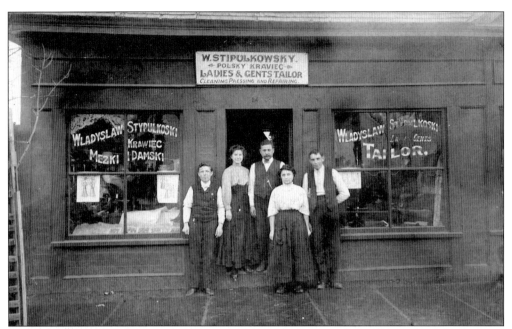

Wladyslaw Stypulkowski (note his name spelled incorrectly on the sign) stands in the doorway of his men's and women's tailor shop and clothing store at 24 Lafayette Street c. 1910. A tailor in his native Male Sewolinki, he brought his skills with him to the New World. Stypulkowski moved to Massachusetts c. 1915. The other people shown are unidentified.

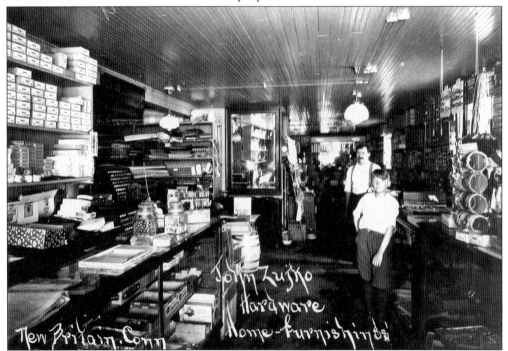

As more and more Poles settled in New Britain, family-owned businesses of all types sprang up to meet their needs. One such was Zujko's Hardware and Paint Store, located at 191 Broad Street. It stayed in business for 75 years. Pictured here are founder Jan Zujko and his son, Edward.

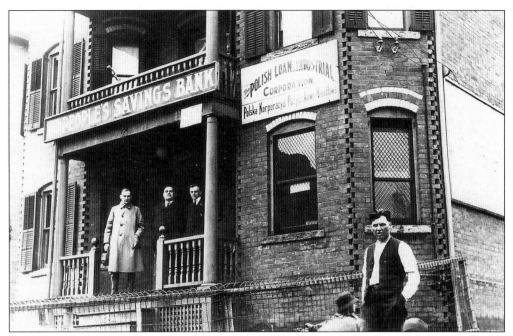

Formed in 1907 under the guidance of Reverend Bojnowski, People's Savings Bank was a place where the city's Poles could handle financial transactions in their own language. It was located for some time in a six-family brick house on Broad Street that was also home to the Polish Loan Industrial Corporation. A full-service bank when it merged with Webster Bank in the 1990s, the institution always retained its Polish character.

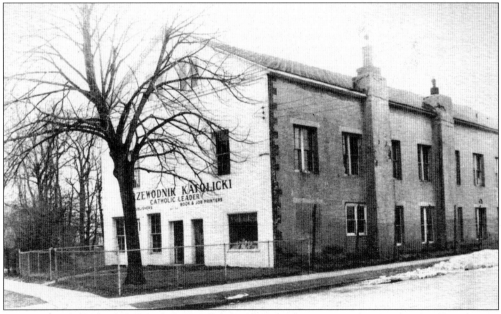

The *Przewodnik Katolicki* (*Catholic Leader*) building at the corner of Burritt and Alden Streets housed the printing presses of this local Polish-language newspaper. Founded by Reverend Bojnowski in 1907, the paper enjoyed a regional circulation until it ceased publication in the late 1960s.

Anna Aleksandra Karmilowicz arrived in New Britain in June 1912 to join her father, Ignacy, then living on Lawlor Street. A talented dancer, she adopted the stage name Sasha Alinova when she joined the cast of the Ziegfeld Follies in New York. The stage shows were known for their elaborate costumes and intricate set designs.

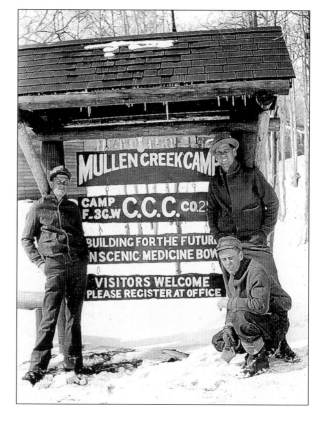

Frank Bryzgiel of Broad Street stands at right with two unidentified coworkers at the entrance of the Mullen Creek Civilian Conservation Corps Camp at Medicine Bow National Forest in Wyoming. The Civilian Conservation Corps was created in 1933 by Pres. Franklin D. Roosevelt to relieve the effects of unemployment caused by the Great Depression. About 500,000 corps members replenished decimated forestlands throughout the nation, planting an estimated three billion trees by 1942.

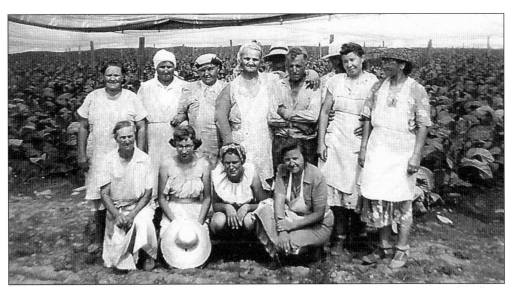

Squinting against the glare of the sun, a group of New Britain women pose for a snapshot in an American Sumatra Tobacco field in the mid 1940s. Shown standing in the second row are, from left to right, ? Stroczkowska, Rose Wieczorek, Hattie ?, ? Pawlicka, their unidentified boss, ? Lawrynowicz, and Bronislawa Malodziejko. Those kneeling and the two men in the rear are unidentified. Numerous workers rode the tobacco bus from New Britain to fields in Bloomfield, Simsbury, and Windsor during the planting and harvest seasons. They earned 25¢ an hour picking tobacco that was used in wrapping cigars.

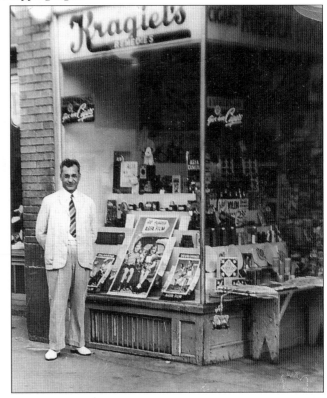

Boleslaw Kragiel poses before the display window of his store at 42 Broad Street. Trained in pharmacy, he mixed remedies for his customers and offered a range of patent medicine and health aids along with candy, film, and camera supplies.

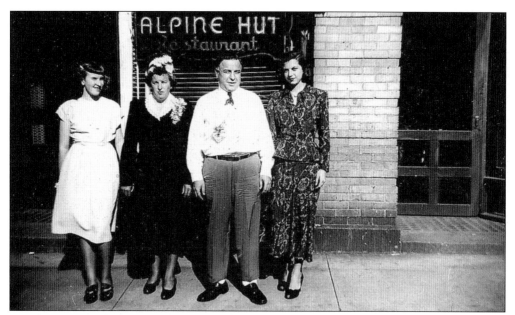

Joseph Kita and his wife, Stella Domurat, stand in front of their 172–174 Arch Street restaurant, the Alpine Hut, in this 1949 photograph. With them are daughters Sophie (left) and Alicia (right). Kita, no stranger to the restaurant business, also owned the Old Keg on Broad Street and the Yankee Restaurant on High Street. He operated the Alpine Hut from *c.* 1947 to 1950.

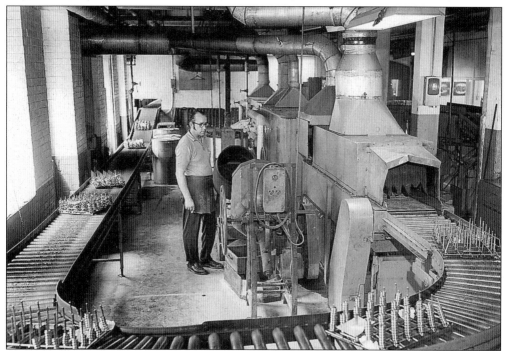

Bronislaw Nowakowski tends to machinery that washes newly produced bearings at Fafnir. Nowakowski came to New Britain from his native Biedrzychow, Ostrow Swietokrzyski, in 1961 to join his brother Edward. He began working at the ball-bearing factory shortly thereafter.

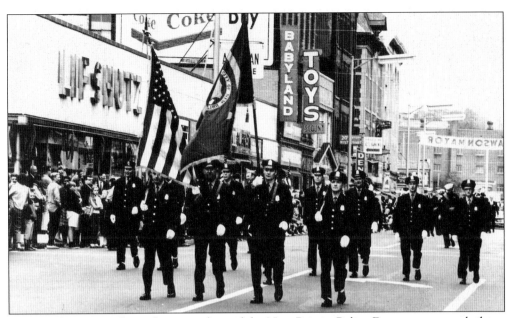

Holding the U.S. and city flags, members of the New Britain Police Department march down Main Street near Myrtle Street in the 1960s. Visible are once-familiar businesses that were razed in the late 1960s for highway construction projects. The contingent of officers included, from left to right, Neville Mahoney, Donald Peters, Ray Kalentkowski, Stanley Murach, Al Valentine, Norman Boulet, Zygfryd Baczewski, Leonard Chiger, and William Kelly.

Judge Lawrence Golon ponders a rendering of the scales of justice adorning his New Britain courtroom. One of New Britain's first lawyers of Polish origin, he began his practice in 1925 and served as alderman for Ward 5 and as judge of the City and Police Court of New Britain. In the 1940s, Golon worked for the U.S. Justice Department's Bureau of Immigration and Naturalization as a special prosecutor.

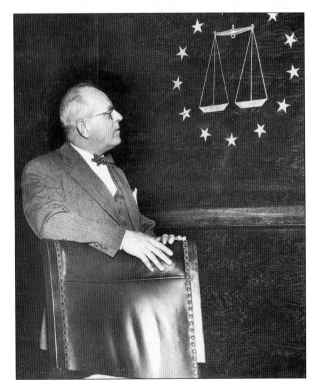

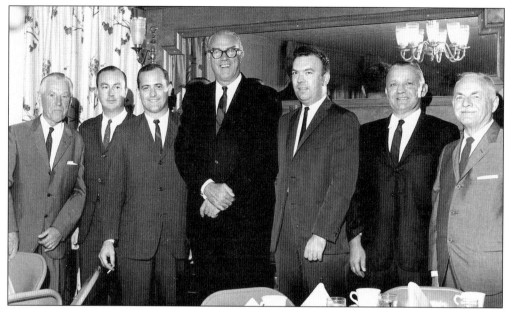

A group of physicians of Polish descent assembles for dinner with friends. Standing in this image are, from left to right, Dr. Walter Blogoslawski, Dr. Joseph Welna, Dr. Stanley Filewicz, New Britain General Hospital administrator Dr. Bliss Clark, Dr. Andrew Wesoly, local industrialist Leo Milewski, and Dr. Ladislaus Slysz.

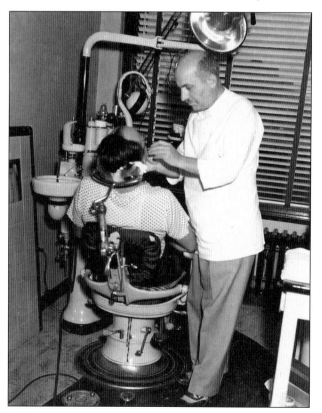

Dr. Peter Bartlewski works on an unidentified patient in this 1953 photograph taken in his dental offices at 300 Main Street. He opened his practice c. 1937 and was active in dentistry until his death in 1964. Bartlewski was a charter member of the 44 Club, an organization of second-generation Polish American professionals.

Six

EDUCATION

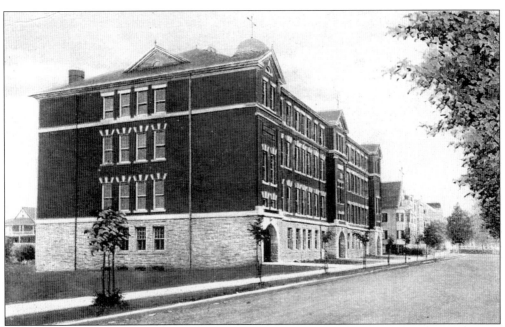

Built in 1910, the original Sacred Heart School stood adjacent to the church on Gold Street. A library occupied the first floor; there were 16 elementary classrooms on the second and third floors and a large assembly hall and stage on the fourth floor. The school also had bath facilities and two swimming pools. It reached its peak enrollment during the 1923–1924 school year, registering 2,114 students.

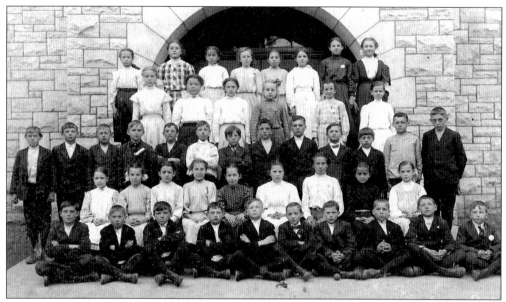

A group of students sits before one of the arches in the old Sacred Heart School in 1912. A bilingual school for many years, Sacred Heart used Polish in the morning to teach catechism, religion, and Polish history and language. Afternoon classes, conducted in English, covered mathematics, geography, the sciences, and history.

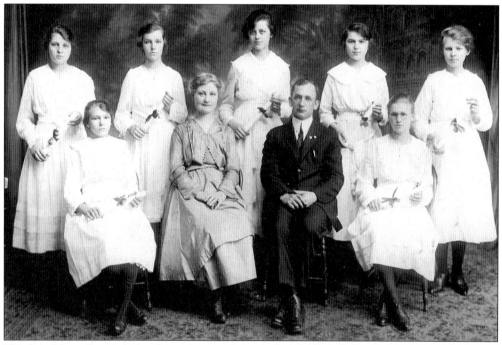

Teacher Mary Smoczynska (seated second from the left) and Prof. Antoni Andrulewicz, a Sacred Heart School teacher and administrator (seated third from the left), are flanked by several members of the 1919 Sacred Heart graduating class. Andrulewicz was principal at Sacred Heart from 1913 to 1919. Smoczynska succeeded him and was principal between 1920 and 1922.

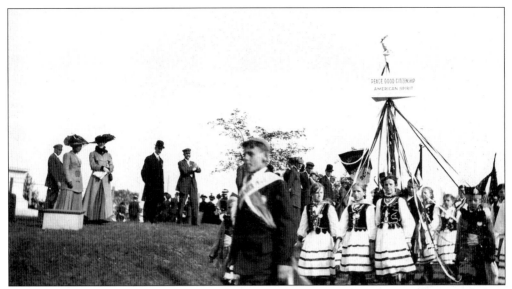

Dressed in Polish folk costumes and bearing a sign extolling good citizenship and American spirit, students from Sacred Heart School march in the Elihu Burritt Day parade on May 10, 1910. Known as the "learned blacksmith," New Britain-born Burritt (1810–1879) was an ardent crusader for universal peace and human brotherhood. The city honored Burritt's legacy and celebrated its own ethnic diversity in this event.

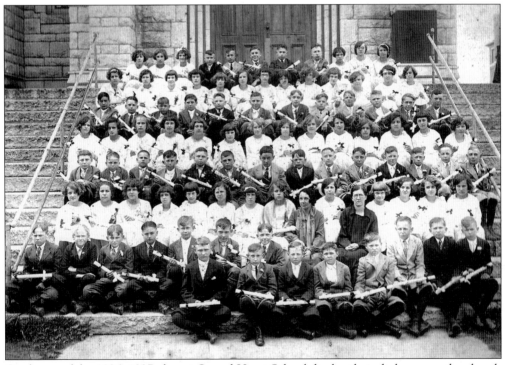

Graduates of the 1926–1927 class at Sacred Heart School display their diplomas on the church steps. Displaying the styles of their era, the girls sport chin-length bobbed hair; the boys, not yet considered old enough for long pants, wear knickers, long dark stockings, and high-topped shoes.

Peter Bartlewski, located sixth from the right in the third row, wears a dark Eton suit in this 1945 kindergarten class photograph. Joining the children in the fourth row is Monsignor Bojnowski. The second Sacred Heart School building, located on Orange Street, was constructed in 1928.

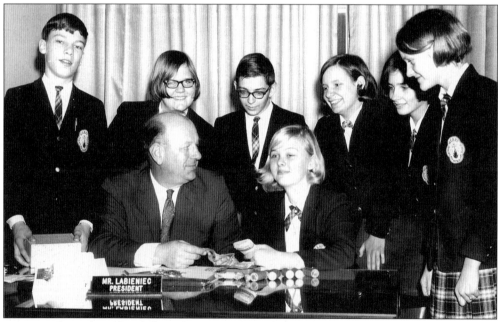

Learning the value of a dollar, some Sacred Heart School students make a deposit of the proceeds of a fund-raiser to People's Savings Bank President Stanley Labieniec. Seated with him is Barbara Deptula. Standing are, from left to right, Alfred Krukowski, Sandra Cavalli, James Makucin, Amy Buslewicz, Deborah Kaszczuk, and Karen Bogden. Labieniec was once named man of the year by the Polish American Professional and Businessmen's Association.

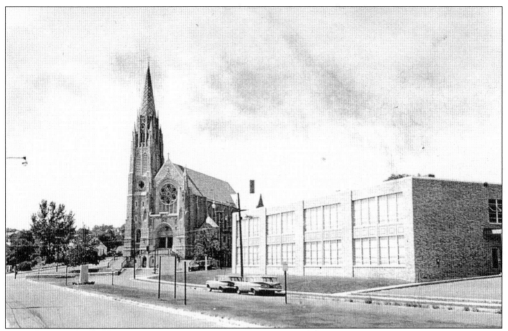

Holy Cross School, located at Farmington Avenue and Eddy Glover Boulevard, was the city's second Polish parish school. Rev. Benedict Sutula was the first principal of the school, which opened in 1954 with 279 students in grades one through nine.

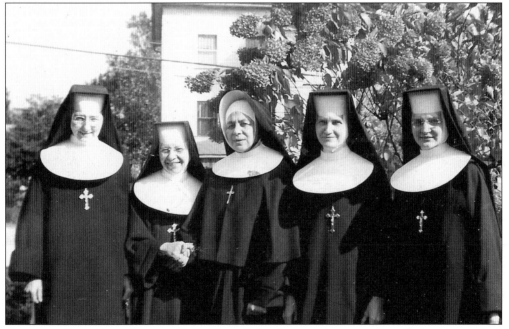

A group of teaching sisters at Holy Cross School entertain an unidentified visiting sister (center). Pictured in this image are, from left to right, the following: Sr. Rupert Cybulski, Sr. Cajetan Polanowski, their unidentified guest, Sr. Thaddea Waraksa, and Sr. Monica Niemira, all members of the Sisters of St. Joseph of the Third Order of St. Francis.

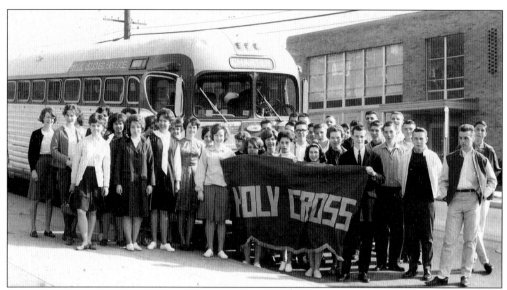

Students from the Holy Cross Catholic Youth Organization (CYO) prepare to board a Corbin charter bus on Farmington Avenue. They are headed for the 1964 World's Fair in New York. The Corbin Avenue Bus Service Company was founded by the Gwiazda family.

Members of the Holy Cross Class of 1966 stand on the school's rear stairs with Pastor John Wodarski (center). Pictured are, from left to right, the following: (first row) Gary Jennings, Stephen ?, Donald Garczewski, Mary Kawiecki, Carol Kochanowicz, Kathy Alegna, Christine Malachowski, Anne Duffy, Gail Topa, Walter Iskra, Andrew Bartlewski, and Peter Klimkiewicz; (second row) Darlene Kulak, Barbara ?, Michelle Koval, Barbara ?, Bernadette Kloczko, Deborah Dzilenski, Peter Grzewinski, John Orzolek, Michael Helechu, Joanne Budrejko, Margaret Ingram, Marcia Dygus, Elaine Haze, Elizabeth Gorski, and Elizabeth Majocha; (third row) Francis Kowalski, William Zieziulewicz, Ronald Bogdanski, Edward Drobinski, Matthew Kozlowski, James Felter, David Dzilenski, Raymond Lewicki, and Robert Cludinski.

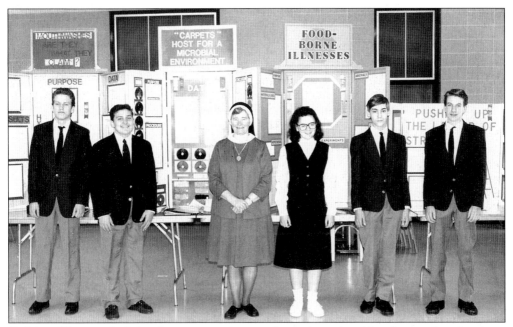

Sr. Mary Christine Jachdowik prepares to inspect the projects that Mary Immaculate Academy students will submit to the Connecticut Science Fair. Students pictured are, from left to right, Christopher Wojtusik, Christopher Waluk, Christine Smilnak, Joseph Wasilewski, and Kevin Papacs.

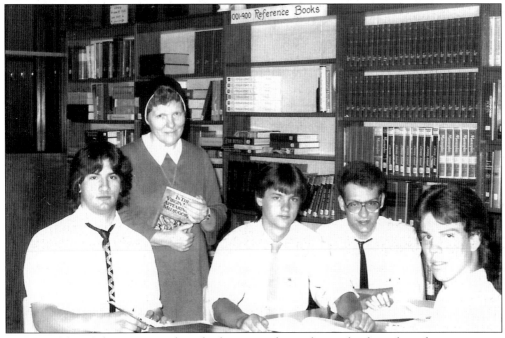

Sr. Mary Alma Sakowicz, a math and religion teacher, selects a book in the reference section of the library at Mary Immaculate Academy (MIA). Originally an all-girls school, MIA opened in September 1945, became coed in 1974, and closed in 2001. Students shown seated are, from left to right, John Rodriguez, Robert ?, Ray Kalentkowski, and Dariusz Orlowski.

JOSEPH KULAK

New Britain, Conn. *"Duke"* August 31, 1917

Joe is a Clark Gable type of boy. Whenever you see him, you see about three girls around trying to swipe his rings or pins. Joe doesn't like studying much, even though he likes the idea of being a stenographer, according to his theory. He is taking stenography and claims to be getting along pretty good.

Baseball; Basketball.

CECELIA KOWALSKI

New Britain, Conn. *"Ciel"* February 14, 1917

"The way to a man's heart is through his stomach"

Judging by "Ciel's" Home Economics marks, any time we want a good meal we know where to go. Are we right "Ciel"? "Ciel" goes in for tennis and biology too (not that we can see any relation between the two.) We are sorry to lose you "Ciel" but good luck to you in the future no matter what you do.

Girls' League.

As the children of the city's first Polish families reached their teenage years, Polish surnames became more and more numerous at New Britain High School. Shown at the top of this page of the 1935 *Beehive*, the school yearbook, are Joseph Kulak and Cecelia Kowalski. They shared the page with Mary Koziatek, Leon Lech, and Florence Kraszewski.

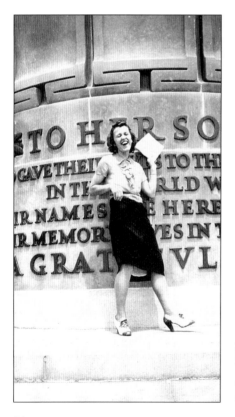

Anna Surowiecki of Silver Street happily displays her NBHS diploma at the War Memorial at Walnut Hill Park in the late 1930s. Surowiecki went on to be an inspector at Stanley Works, where she was employed for many years.

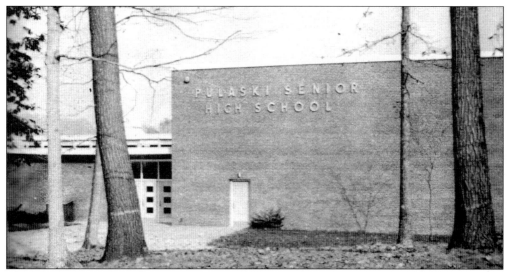

The post-World-War-II baby boom necessitated the construction of a second public high school in New Britain. Members of the Polish community successfully petitioned that the new school be named after Revolutionary War hero Gen. Kazimierz Pulaski. Located on Farmington Avenue, it functioned as Pulaski High School from 1961 to 1982. When demographics shifted, it became Pulaski Middle School.

Connecticut State Board of Education

EVENING SCHOOL CERTIFICATE

This certifies that ___Walerya Filipek___ was instructed

for ___75___ Sessions in the Advanced Class for Non-English Speaking Adults in the

___Washington___ School of the Town of ___New Britain___

for the term ending ___March 26 1929___.

_____	_____
Teacher	Secretary and Commissioner of Education
_____	_____
Superintendent of Schools	State Director of Adult Education
(To be signed by the Superintendent if promotion is recommended.)	

Waleria Filipek was awarded this certificate of graduation from an advanced class for non-English-speaking adults held at Washington School in 1929. Many immigrant parents attended English language and Americanization classes in the city's public schools at night, wanting to keep pace with what their children were learning at school during the day.

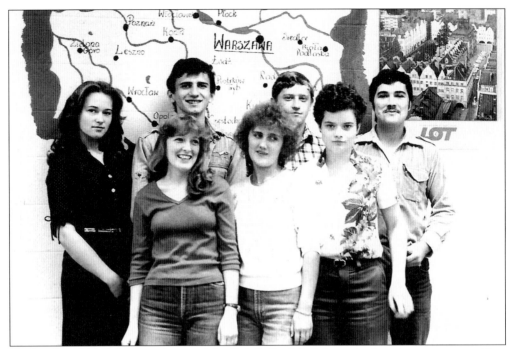

Students in one of the first classes of the Polish-English bilingual education program at New Britain High School stand before a map of Poland they painted on their classroom wall. Pictured are, from left to right, the following: (first row) Maria Gabrysz, Czeslawa Rembowicz, and Danuta Chorzepa; (second row) Barbara Wielblad, Dariusz Madejski, Piotr Czajkowski, and Henryk Jankowski. New Britain's federally mandated program was one of the first in the nation.

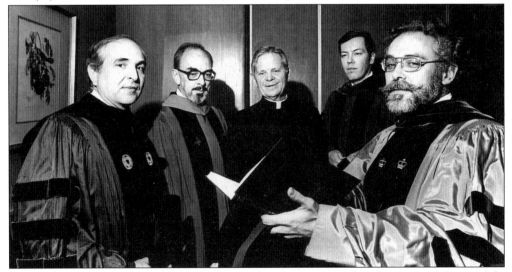

Msgr. John Wodarski (center) of Holy Cross Church is presented with a copy of *Pastor of the Poles: Polish American Essays*, a Festschrift written in his honor at Central Connecticut State University (CCSU). The monograph was published in 1982 by CCSU's Polish Studies Program. Shown here are, from left to right, Prof. Thaddeus Gromada, Dean William Brown, Wodarski, Prof. Mieczyslaw Biskupski, and Prof. Stanislaus Blejwas, Polish studies program coordinator. The program, established in 1974, is one of only a few of its kind in the United States.

Seven

FIGHTING FOR THE HOMELAND

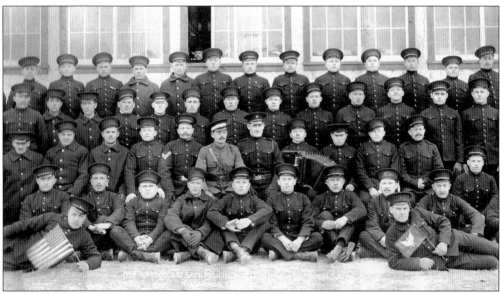

"*Ojczyzna wzywa was*" (the Fatherland is calling you) appeared on posters throughout Polish America during World War I, urging immigrants to join the Polish Army in France and liberate the occupied homeland from the German kaiser's control. This platoon, in uniform and displaying U.S. and Polish flags, represents a fraction of the 300 New Britain men who enlisted to fight under Polish general Jozef Haller.

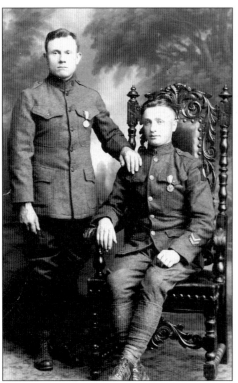

New Britain residents Stanislaw Malinowski, born in Chrzanowo, Lomza, and Marian Hermanowski, a native of Poniat, Lomza, both volunteered for service in the U.S. Army in World War I. Malinowski served with the 151st Depot Brigade and Hermanowski served with the 82nd Division in France. In New Britain, nearly 700 Polish immigrants and their American-born sons enlisted in the U.S. armed forces.

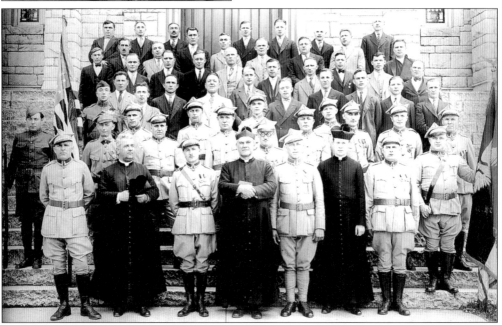

Recently returned veterans of Haller's Blue Army, so named for the color of their uniforms, stand with Reverend Bojnowski, their recruiter, on the steps of Sacred Heart Church. In 1920, these former volunteers of the Polish Army in exile founded the General Jozef Haller Post 111 of the Association of Polish Army Veterans. The post is headquartered in a brick building built in 1951 at Broad and Grove Streets.

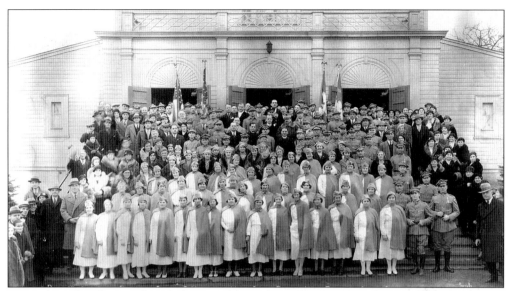

General Jozef Haller stands with former soldiers, the Haller Post Auxiliary, and parishioners on the front steps of the old Holy Cross Church during a visit to New Britain in 1934. The former commander in chief of the Polish forces was on a U.S. tour of Polish American communities to discuss issues affecting Polish war invalids and orphans.

NO. _____ CHICAGO, _____ 19___

NATIONAL POLISH DEPARTMENT OF AMERICA

2138 PIERCE AVENUE, CHICAGO, ILL.

THIS CERTIFIES THAT WE HAVE RECEIVED WITH THANKS THE SUM OF
NINIEJSZEM KWITUJĘ Z PODZIĘKOWANIEM ODBIÓR SUMY

Dolarów tysiąc czterysta dziewięćdziesiąt ośmi 99/00

PAID INTO TREASURY OF THE NATIONAL POLISH DEPARTMENT BY
WPŁACONEJ DO KASY WYDZIAŁU NARODOWEGO POLSKIEGO PRZEZ

Kom. Ob. par. Najśl. Ser. Jez. śp. Ks. L. Bojnowski New Britain Conn.

FOR
NA Sieroty w Polsce

NATIONAL POLISH DEPARTMENT

$1,498.99

TREASURER
SKARBNIK

This receipt, dated November 11, 1919, is from the National Polish Department to Rev. Lucjan Bojnowski and acknowledges a $1,489 donation for the orphans' fund. Bojnowski was actively involved in fund-raising for war causes and for those furthering Polish independence in the years preceding, during, and subsequent to World War I. An impressive $300,000 was collected from New Britain's Polonia during this period.

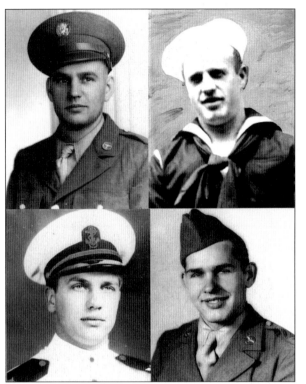

Four sons of Aleksander and Amelia Repczynski served in various branches of the U.S. armed forces during World War II. At the top left is Walter Repczynski, who was stationed in Africa and serviced aircraft in the U.S. Army Air Force. At the top right is John Repczynski, a Purple Heart recipient, who was killed in action aboard the USS *Savannah* during the invasion of Salerno on September 11, 1943; he is buried at the military cemetery in Nettuno, Italy. At the bottom left is Joseph Repczynski, a U.S. Navy Air Force lieutenant who served as a fighter pilot in the Pacific. At the bottom right is Lucian Repczynski, a sergeant in the U.S. Army Air Corps' B-25 Mitchell group, renowned for its combat record in the Italian and Tunisian campaigns.

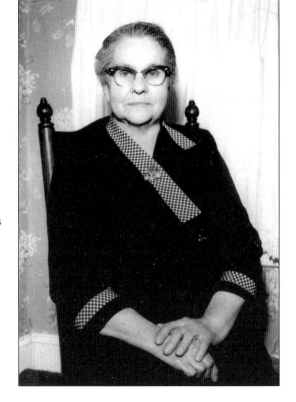

Amelia Repczynski, the mother of the four servicemen pictured above, was one of approximately sixty Gold Star Mothers from New Britain's three Polish parishes. Born in Brzozowo in Dabrowa Bialostocka parish, Amelia Boruch married Aleksander Repczynski in Providence, Rhode Island, in 1905 and resided in New Britain for more than 70 years. Beginning in World War I, window service flags with blue stars signified family, business, or group members in the U.S. armed forces; gold stars honored those who had died.

Dr. Andrew Wesoly, called to active service in 1940, was a U.S. Army captain in the Second World War. He was instrumental in setting up the 8th Station Hospital on Bora Bora in French Polynesia. He served in the Medical Corps until his discharge in 1945. Upon returning to his native New Britain, Wesoly opened his medical practice and also served as the physician for the New Britain Fire Department.

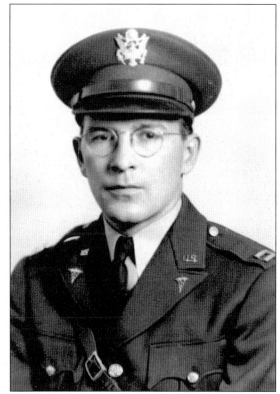

Men of the New Britain units of the 169th Infantry, 43rd Infantry Division, pause outside their barracks in Camp Blanding, Florida, in 1942. Among those pictured are Sgt. Peter Baranowski (third from the right) and Sgt. Frank Bryzgiel (squatting), both of Company I. One of New Britain's municipal parking garages is named after another sergeant from this company, Henry Szczesny, who was killed in action in the Philippines in 1945.

The Ziolkowski brothers, Carl (left) and Stanley (right), pose with their parents, Jan and Michalina Ryniec Ziolkowski, in the back yard of their Clinton Street home in 1944. The brothers happened to be on leave from the U.S. Army at the same time.

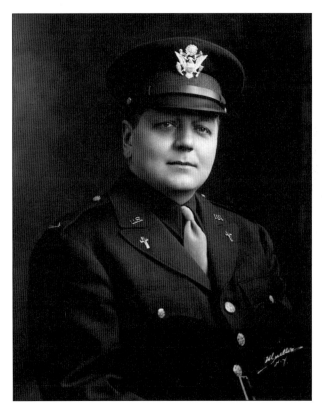

Msgr. and Brig. Gen. Alphonse Fiedorczyk, son of Wincenty and Tekla Bezrudczyk Fiedorczyk, began his religious career at Sacred Heart Parish. In 1944, he volunteered for military service and was a chaplain in Europe and the Far East for more than 26 years. The New Britain native retired from the priesthood from Holy Name Parish in Stamford.

First Lt. Mary Wesoly Zurek takes a rest from her duties in the Army Nurse Corps in the Philippines during World War II. Zurek earned several commendations for her service, including the Asiatic-Pacific Campaign medal and a meritorious unit commendation. She was one of more than 12,000 military nurses who were stationed overseas by 1944.

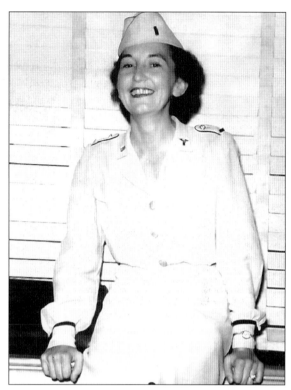

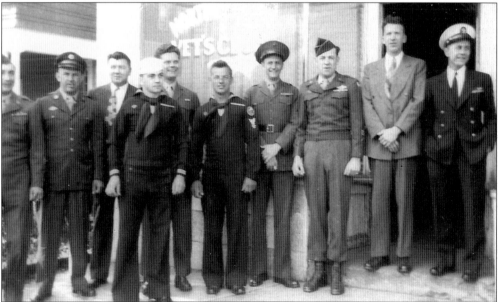

The Northwestern TGM Memorial Post started as an athletic club. After World War II, veterans from the largely Polish northwestern section of the city transformed the club into a veterans organization. Of the 25 charter members, 24 were Polish. Standing in front of the club's first quarters on upper Broad Street are, from left to right, unidentified, John Hoczyk, Walter Lonski, unidentified, Walter Borawski, Felix Hoczyk, Walter Rogala, Joseph Zyjewski, Edward Zyjewski, and Tim Borawski.

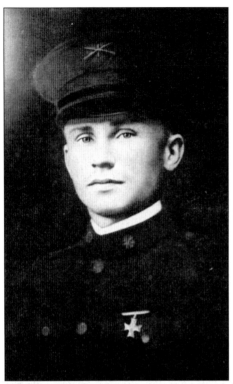

Joseph Sakowicz of Willow Street was New Britain's first American soldier of Polish descent to be killed in action in World War I. A skillful drill sergeant of Company I, 102nd Infantry, he died in France during the Battle of Seicheprey on April 20, 1918. The New Britain Polish Legion of American Veterans (PLAV) post is named in his honor.

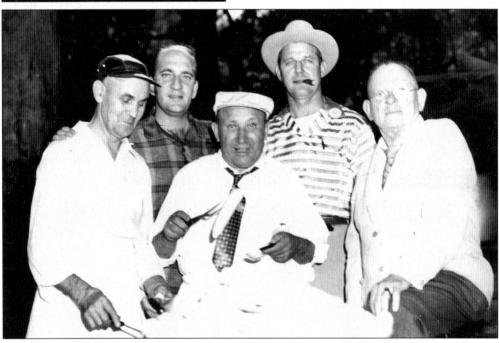

Steaming corn at the annual family picnic of the Sergeant Joseph Sakowicz Post, PLAV, are, from left to right, the following: (first row) John Wilk, Anthony Czuprynski, and Julius Gavelek; (second row) Henry Gromak and post commander Edward Baldyga. The picnic took place at Schuetzen Park on September 28, 1958.

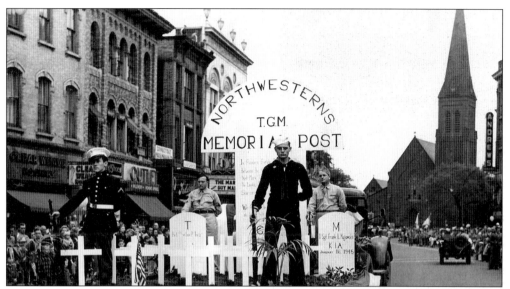

Uniformed veterans of the TGM Post pass through Main Street on their parade float c. 1955. The float bears mock gravestones of three fallen comrades of the 43rd Infantry Division, after whom the post is named: privates Stanley Todzia and Edward Giramonti, who perished on New Georgia Island in the summer of 1943, and Tech. Sgt. Frank Majewski, who was killed January 16, 1945, in Luzon in the Philippines.

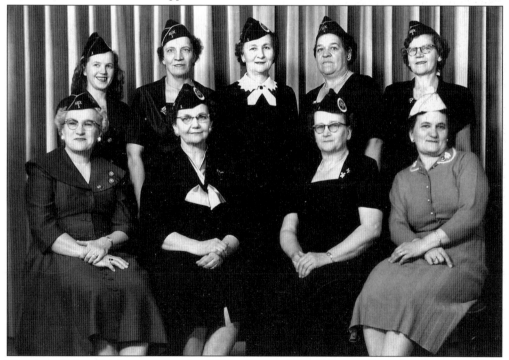

Wearing their official post caps, the 1955 officers of the Sakowicz Post Auxiliary pose for a formal portrait. Pictured are, from left to right, the following: (first row) Stella Szostek, Tessie Wilk, Nellie Biedka, and Katherine Lempicki; (second row) Helen Krawiec, Mary Jablonski, unidentified, Anna Hermanowski, and Eleanor Zawadzki.

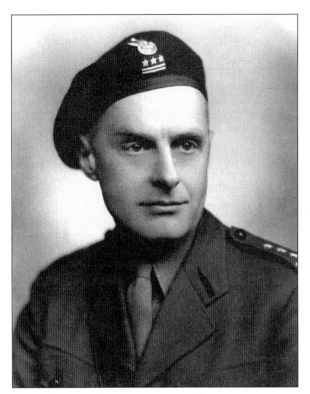

One of several high-ranking Polish Army career officers to settle in New Britain after the Second World War, Col. Jan Jerzy Narzymski began his military career at age 19, when he was drafted into the Imperial Austrian Army during World War I. The next decades saw him as a prisoner of war in Tashkent, a military attaché of the Polish government in exile in Switzerland, and the manager of a farm in Devonshire, England.

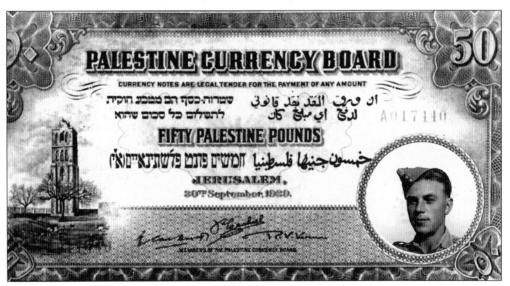

Ludwik Szydelko's photograph appears on this 1943 souvenir Palestinian "currency" written in Arabic, Hebrew, and English. A native of Tuliglowy, Szydelko served in the 15th Poznan Lancers Division of the Polish Army. The upheavals of war took him to Siberia, Iraq, Palestine, Egypt, Italy, England, and finally, in December 1951, to New Britain.

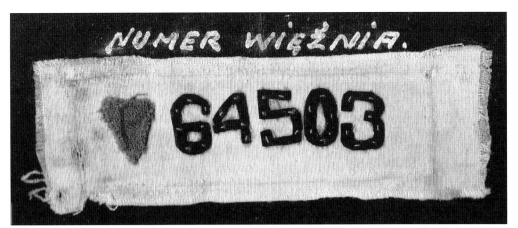

Wlodzimierz Lausch, a Poznan native, was interred in Nazi concentration camps in Mauthausen and Gusen, Germany, for two years during World War II. As a political prisoner, he wore this numbered armband; a "P" in a red triangle identified him as a Pole. After his release, Lausch made his way through Austria, Italy, and England before arriving in the United States and settling in New Britain in 1952.

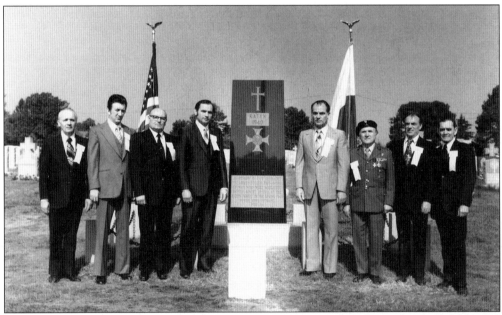

Polish veterans unveil the first monument erected in the United States in memory of the 1940 Katyn Forest massacre of more than 4,000 Polish prisoners of war by Soviet forces. Participating in the May 1980 dedication at Sacred Heart Cemetery are, from left to right, Wladyslaw Fin, Jan Niebrzydowski, state representative Dominik Swieszkowski, Mieczyslaw Kierklo, Jan Markow, Kazimierz Swiatocho, Ludwik Wojcik, and Jan Wojcik.

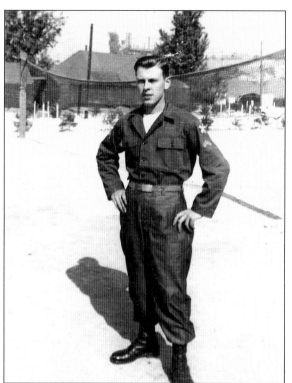

Henry Deptula stands in the recreation area of a military base in Korea. Deptula served with the 52nd replacement battalion in Korea from 1951 to 1953.

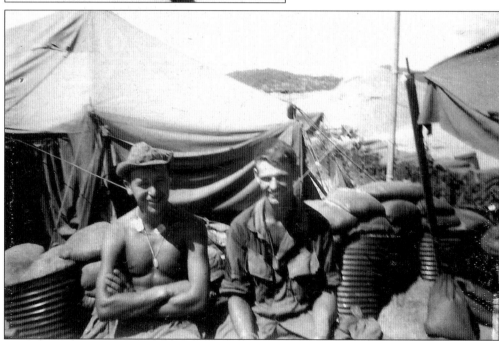

Anthony Dudanowicz (left) of Delta Company, 3rd Platoon, 1st Squadron of the 27th Engineers Battalion, 101st Airborne Division, sits near an encampment near Gia Le, Vietnam. Dudanowicz served in Vietnam in 1968 and 1969. Born in Szypliszki, Suwalki, he immigrated to the United States with his family in 1965.

Eight

POLITICAL LIFE

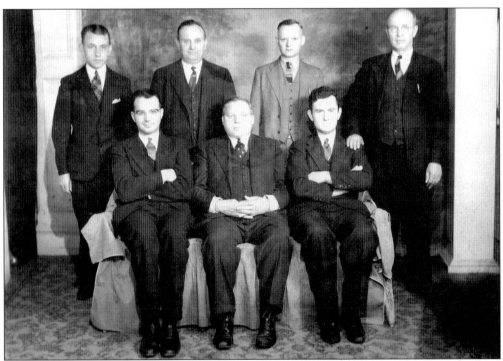

Officers of the Pulaski Democratic Club pose for a formal photograph. Piotr Rutkowski is seated at the center; the other men are unidentified. Named in honor of the famous Polish patriot and Revolutionary War hero, the club was founded in May 1931. Its primary mission was to support and sponsor candidates of Polish origin in their bids for municipal and state offices. It encouraged voter registration and took a general interest in quality of life issues affecting the Polish community.

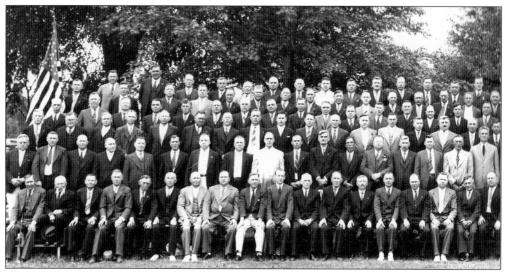

Members of the Polish Political Club No. 1 gather for a group photograph in a local park. The organization, founded in 1900 through the efforts of Wincenty Juchniewicz and Tomasz Makarewicz, provided schooling for citizenship exams and functioned as a mutual benefit society as well. It remained active for 80 years.

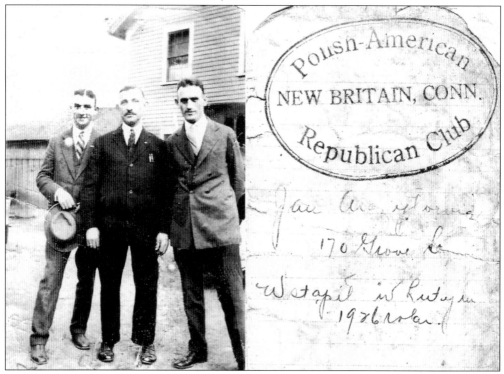

Jan Arzylowicz (center) and his sons Walter (left) and Jake (right), photographed in 1925, were early members of the Polish American Republican Club. In the 1930s, the city's Polish Republicans reorganized and established the Oaks Club, named for two sturdy oaks that stood on the property of organizer Joseph Kowalczyk. The club is located on Washington Street near the Falcon building.

Eddy-Glover Unit No. 6
American Legion Auxiliary

aims to foster and perpetuate 100% Americanism. Loyal students mean loyal Americans. Therefore, this certificate is awarded to

Valerya Filepek

in appreciation of perfect attendance at night school during the season of *1928-'29* in the *Foreign Adult Classes*

New Britain, Connecticut

Harriett B. Mitchell Unit President

March 26, 1929.

Elsie C. Emsworth, Chairman Americanism

Pictured is Valeria Filipek's certificate from an Americanization class for adults sponsored by the Eddy Glover Post of the American Legion in 1929. Many adults pursued night school programs to learn English, U.S. history, civics, and American customs and practices in order to better assimilate into the larger community.

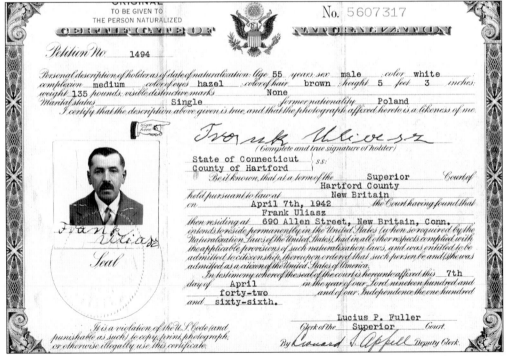

A photograph of Frank Uliasz adorns his 1942 certificate of naturalization, issued by the Hartford County Superior Court at New Britain. Born in Rogi, Galicia, Uliasz worked for the City of New Britain and resided on Allen Street. Immigrants seeking American citizenship were eligible to file a declaration of intention, commonly called first papers, after three years' residence in the United States, and could file a petition for naturalization, called second papers, two years later.

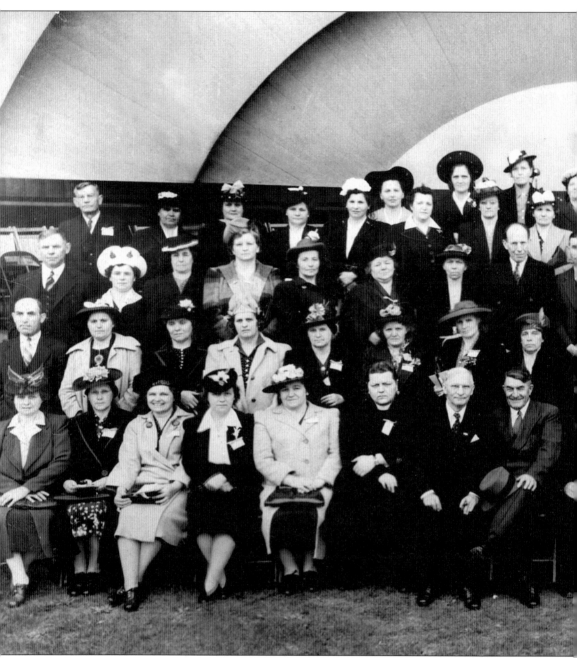

In the presence of more than 4,000 of their fellow New Britainites, 197 new citizens of the United States received their naturalization certificates from Hartford County Superior Court Judge William Shea on May 16, 1943. A colorful "I Am an American Day" ceremony was held at the Darius Miller Music Shell in Walnut Hill Park. A parade through the city's center to the park included the Corbin Screw Corporation Band, the New Britain High School Choir, and marching units of various local organizations. The invocation was given by Rev. Alphonse Fiedorczyk of

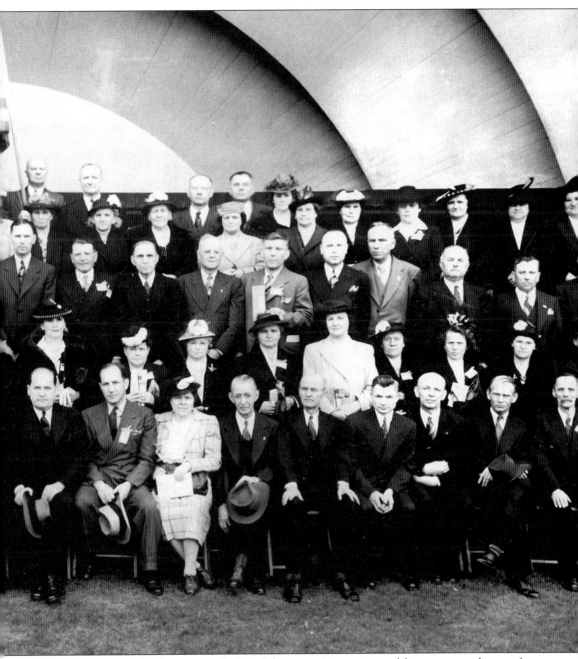

Sacred Heart Church. Approximately 80 of the new citizens pictured here were graduates of a citizenship class sponsored by the Pulaski Democratic Club and taught by A. J. Karpinski. Naturalization rates rose dramatically during World War II, due to urging from employers and to a sense of duty felt by many immigrants who had sons fighting in the U.S. military. Reverend Bojnowski is seated in the first row, ninth from the left. The woman in the white coat in the second row, 14th from the left, is Zofia Bryzgiel, coauthor Jonathan Shea's grandmother.

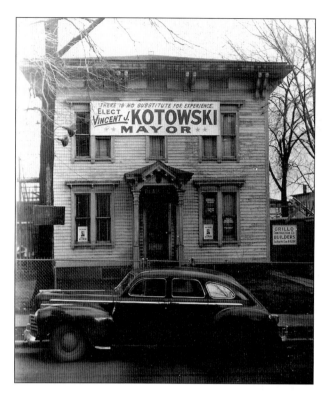

A banner supporting mayoral candidate Vincent Kotowski hangs from the old Pulaski Democratic Club, adjacent to the present club's location on Grove Street. In tandem with its political activities, the club had an educational and cultural focus. It offered citizenship classes and scholarships, and it was instrumental in the construction of the Pulaski Monument at Broad and Burritt Streets and in naming the city's second public high school after Casimir Pulaski.

Leading the Pulaski Democratic Club's Women's Auxiliary in the 1960s are, from left to right, the following: (first row) officers Stella Badura, Anna Majewicz, and Eleanora Archacka; (second row) Zofia Szewczak and unidentified. The auxiliary, founded in 1934, encouraged Polish women to play an active role in local politics.

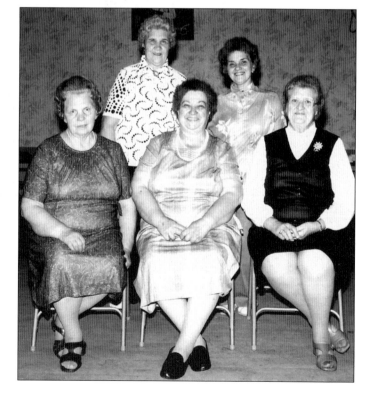

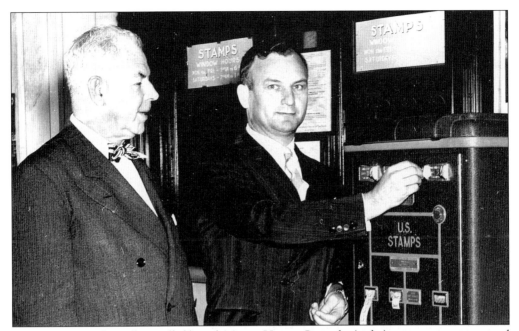

Postmaster Joseph Halloran (left) and Mayor Henry Gwiazda (right) test a new automated postage machine at the old New Britain post office on West Main Street. Gwiazda was New Britain's first Polish American mayor. He served two terms, from 1946 to 1950, and went on to a lengthy career as a probate court judge from 1954 to 1978.

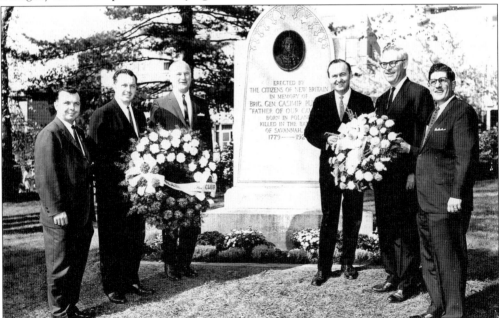

Local politicians participate in a wreath-laying ceremony at Pulaski Park at Broad and Burritt streets c. 1965. Pictured are, from left to right, Alderman Henry Wasik, Mayor Paul Manafort, probate court judge Henry Gwiazda, former mayor James Dawson, and Joseph Cannata, chairman of the Columbus-Pulaski Day Parade Committee. A parade is held on Broad Street every October in honor of Brig. Gen. Casimir Pulaski's birthday.

Julius Kremski, New Britain's second mayor of Polish origin, throws out the ceremonial opening pitch at a Falcon Club baseball game. Kremski's term as the city's highest-ranking official lasted from 1960 to 1962.

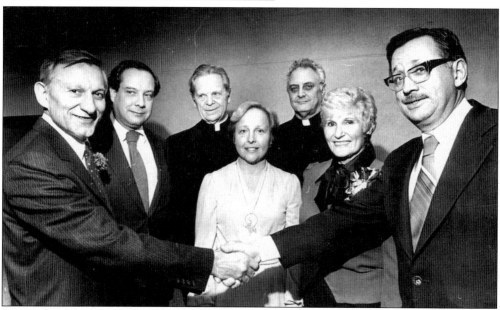

Stanley Pac (far left) accepts congratulations from attorney Stanley Traceski Jr. (far right) on being named 1983 Man of the Year by the Polish Businessmen's and Professional Association. Standing between them are, from left to right, attorney William Buzanowski, Msgr. John Wodarski, Congresswoman Nancy Johnson, Rev. Augustine Giusani, and Genevieve Pac, the honoree's wife. Pac was elected mayor of New Britain in 1971; he also served as Connecticut's commissioner of environmental protection from 1977 to 1987.

A swearing-in brings together two sons of Erin with Polish connections: New Britain mayor William McNamara (left) listens as city clerk Richard Murphy (right) administers the oath of office to him in 1977. Visible overhead is the wrought-iron seal of the city at the main entrance to city hall. McNamara is the grandson of Polish immigrants; Murphy is married to the former Estelle Lazarski.

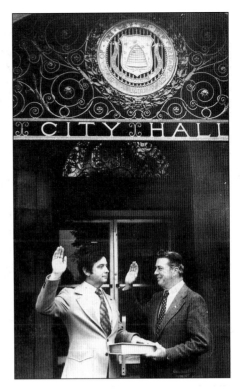

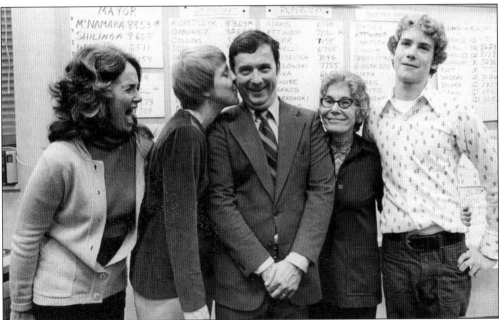

William McNamara receives a victory kiss from his wife, Saundra, after his win in the 1977 mayoral election. Pictured with him are his sister Kathy (at the far left) and his mother, Helen, and son Kevin (at the right). A former English and German teacher at the city's high schools, McNamara is the grandson of Jakub and Malgorzata Kobrzynska Malinowski, former residents of Alden Street.

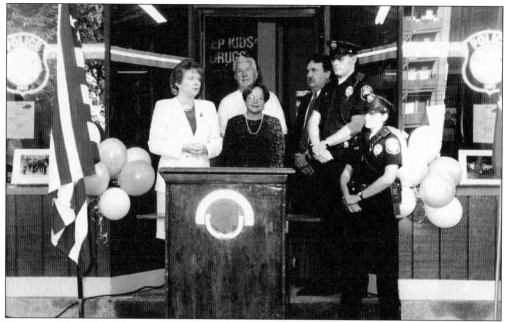

Mayor Linda Blogoslawski (far left) presides over the opening of the New Britain Police Department's substation at Glen Street and Rockwell Avenue in 1993. Standing with her are, from left to right, Alderman Robert Balocki, U.S. Rep. Nancy Johnson, police chief William Sencio, officer Chris Williams, and officer Deborah Betterini.

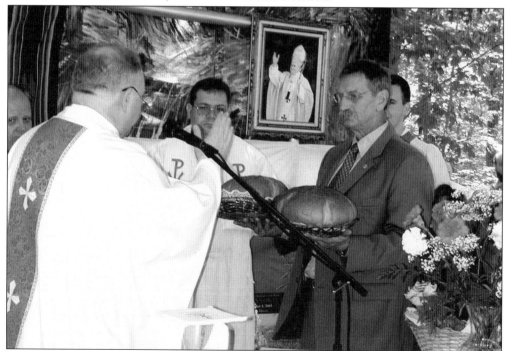

Belgian-born Lucian J. Pawlak, New Britain's last Polish mayor of the 20th century, presents the traditional bread to Msgr. Daniel Plocharczyk at the *Dozynki* harvest festival at Falcon Field. Looking on is Rev. Arkadiusz Snigier, a visiting priest from Poland.

State Rep. Leon Hermanowski makes a point while addressing the Connecticut State Legislature in Hartford. The son of Aleksander and Josephine Mierzejewski, he was active in local and state politics all his life. He began his career as an alderman in New Britain, serving terms from 1954 to 1961, and served his district in the legislature from 1970 to 1976. Hermanowski was one of the main organizers of the TGM veterans post; his tenure as commander lasted about two decades.

Democrat Lucien Maciora of New Britain served in the 77th U.S. Congress as a member of the House of Representatives from 1941 to 1943. Politically involved for much of his career, Maciora was also the chairman of the New Britain Police Commission and worked as municipal tax collector from 1950 to 1969.

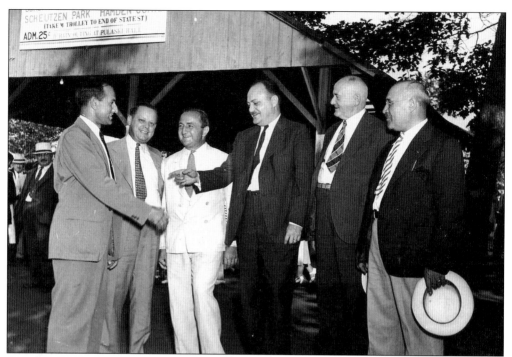

Congressman Boleslaus Monkiewicz jokes with fellow Republicans at an outing sponsored by the Polish Young Men's Republican Club in New Haven c. 1938. A local circuit court judge and onetime member of the U.S. Parole Board, Monkiewicz served two terms in Congress, from 1939 to 1941 and from 1943 to 1945.

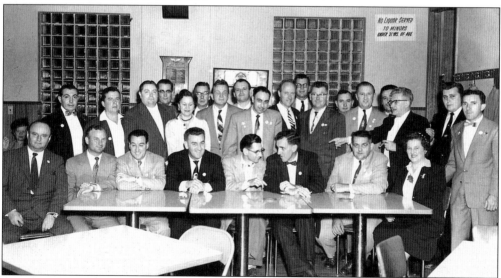

Maine governor Edmund Muskie (originally Marciszewski) visits with local Democratic labor leaders and politicians at the Pulaski Democratic Club in October 1954 to discuss unemployment and the country's economic situation. Seated are, from left to right, Judge S. Googel, Henry Gwiazda, John Dempsey (elected governor of Connecticut in 1961), two unidentified people, Governor Muskie, unidentified, and Elizabeth Zdunczyk. Those standing are unidentified.

Nine

ATHLETICS

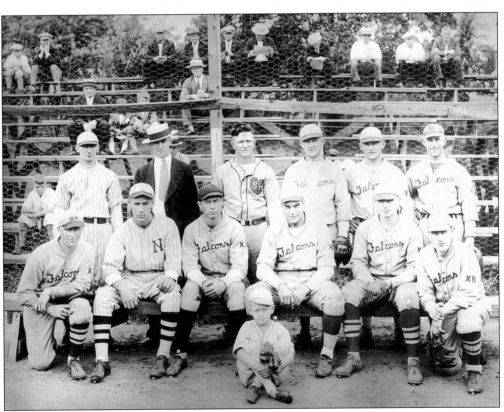

As some fans sit and wait in the bleachers, the 1921 Falcons baseball team gets ready for a game at a local ball field. Identified in the second row are Stanley "Starhead" Budnik (fourth from the left), Simon Budnik (fifth), and Joseph Kowalczyk (sixth).

New Britain's Polish Falcon Nest 88 gymnastics team forms a human pyramid in this 1920 photograph. The "SP" on their shirts stands for *Sokolstwo Polskie*, the group's name in Polish. Dedicated to sports and fitness, the Falcons were founded in Poland in 1867; emigration made them an international organization. The New Britain chapter, or nest, was founded in 1907.

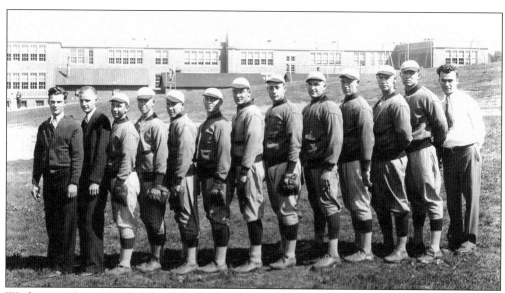

Washington Junior High School, located at High and Carmody Streets, serves as the backdrop for this photograph of the championship 1932 Falcons baseball team. Pictured are, from left to right, A. Jakubowicz, J. Partyka, ? Dobrowolski (manager), J. Golas, "Tud" Flood, P. Zapatka, N. Lipman, H. Beagle, A. Sulik, S. Partyka, T. Blanchard, M. Kulas, and J. Cabaj (coach). Team members not pictured are C. Krenar and C. Wojack (captain).

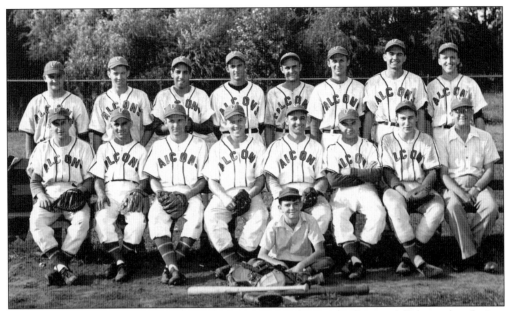

The members of the 1949 Falcons baseball team were the city and central Connecticut league champions. Seated behind team mascot G. Crean Jr. are, from left to right, the following: (first row) T. Kaczynski, E. Torello, J. Piscoty, F. Helmsley, W. Chadwick, J. Cabaj (coach), J. Dobek, and G. Crean (scorekeeper); (second row) W. Bezrudczyk, L. Miller, D, Sargis, A. Blanchard, C. Domuracki (captain), E. Olis, J. Perotta, and B. Clynes.

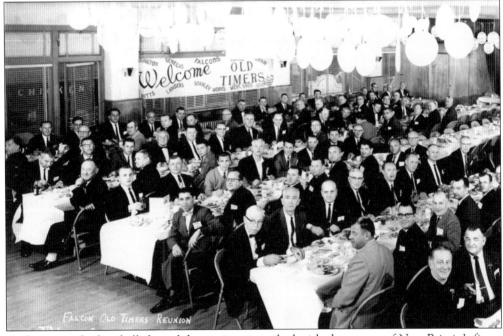

Gathering under baseball-shaped decorations inscribed with the names of New Britain's finest athletes, the "Old Timers," a group of former athletes, celebrate their seventh annual reunion at Falcon Hall in 1963. Visible through the open window blinds is the familiar "Chickens" sign of the Universal Poultry Market on Broad Street.

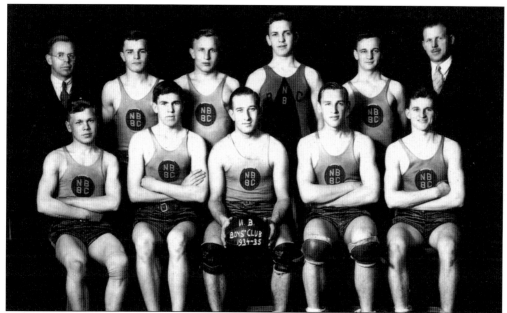

Polish Americans comprise half of the 1934–1935 New Britain Boys Club basketball team. Pictured are, from left to right, the following: (first row) Peter Gut, Paul Bakanas, Carl Boehnert, Harry Jacunski, and Vinny Zandzukas; (second row) Dwight Skinner, Walter Dygus, Tony Pawlikowski, Chester Adamowicz, Ray Augustyn, and Ray Anderson.

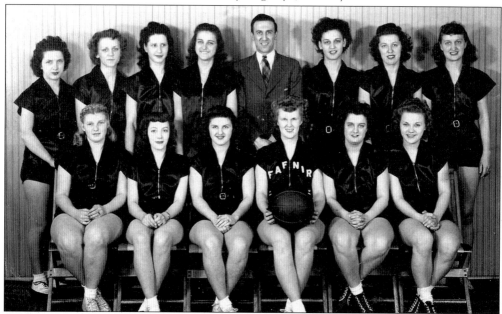

Dressed in their black satin uniforms are the members of Fafnir's women's basketball team. They are, from left to right, the following: (first row) Mary Lesczynski, Julia DiFrancesco, Mary Delbarba, Irene Dobosz, Rita Doucette, and Lola Iskra; (second row) Catherine Badolato, Geraldine Snyder, Henrietta Sulkowski, Georgette Doucette, Santo Capodice (coach), Helen Bryzgiel, Florence Kaminsky, and Florence Mikulski. The Fafnir women won the 1946–1947 Industrial League Basketball Championship.

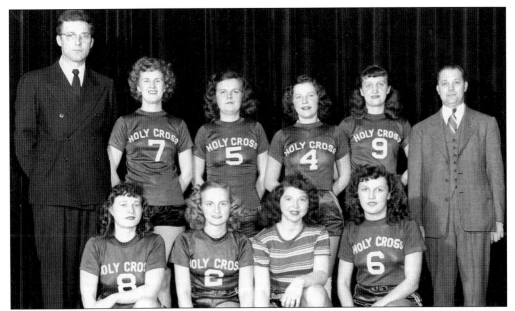

The Holy Cross women won the 1946–1947 State Polish League Women's Basketball Championship. Team members are, from left to right, the following: (first row) Veronica Rutkowski, Lucy Chanko, Helen Pacyna, and Sophie Kisluk; (second row) Ed Szczepanik (coach), Irene Dobosz, unidentified, Florence Labieniec, Florence Mikulski, and Leo Plaszczynski (manager).

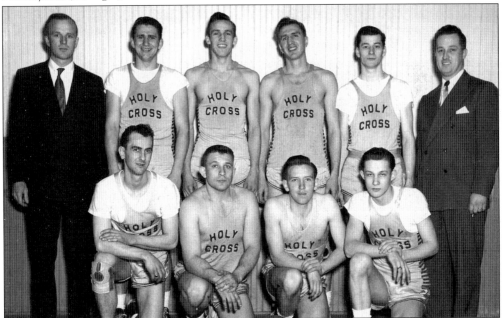

Holy Cross claimed the 1950–1951 State Polish Basketball League championship. Pictured are, from left to right, the following: (first row) Matt Tyska, Ed Boiczyk, Paul Wesoly, and Don Zoroski; (second row) Casimir Dygus (manager), Paul Baczewski, Stan Sytulek, Joe Deutsch, Ted Wolski, and Frank Dobek (coach). Team members not present for the photograph were Dan Majewski, Henry Buckowski, and Walter Kachnowski.

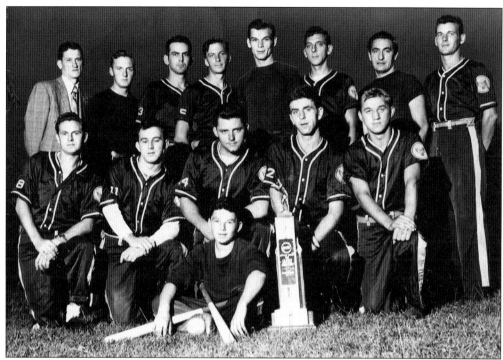

The TGM veterans post captured a Connecticut state softball championship in 1949. Pictured with the trophy and bats is mascot Richard Drezek. Team members are, from left to right, the following: (first row) Ted Rapacz, Ed Wojas, Stan "Parker" Lodzinski, Hank Chmura, and Joe Hoczyk; (second row) Nick Lapinski, Bill Anderson (manager), Chet Pietras, Joe Dzioba, Hank Raducha, Ed Samojla, Ernie Argazzi, and Hank Parda. Absent were Ed Zembko and Joe Pastore.

Harry Nowobilski, one of New Britain's most well-known golfers, is shown during the finals of the 1965 Stan Pisk Trophy Tournament at Stanley Municipal Golf Course. His golfing accomplishments include four New Britain city titles. In 1970 and 1972, he and his son John won the Connecticut Golf Association's state father and son title.

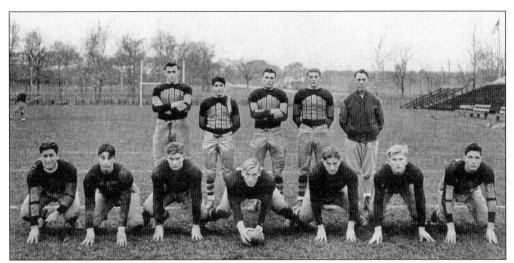

The New Britain High School Golden Hurricanes won the 1935 state football championship. Team members included, from left to right, the following: (first row) Michael Cimino, Joseph Apisso, Leo Lech, Harry Jacunski, Michael Seich, John Bogdan, and Welles Eddy; (second row) Wasily Zaiko, James Meligonis, Joseph Granski, Frank Tyburski, and Charles "Chick" Shea (coach). Jacunski went on to play on the 1939 and 1944 NFL Green Bay Packers championship teams.

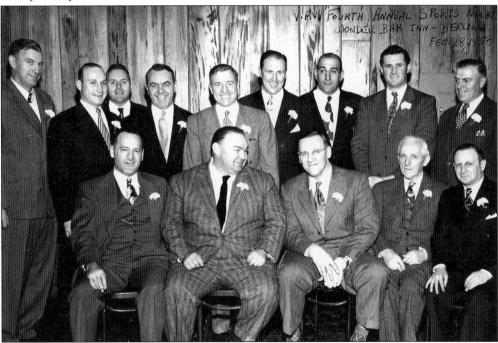

The VFW's fourth annual Sports Night, held at the Wonder Bar Inn in Berlin on February 28, 1950, attracted several prominent figures. Pictured are, from left to right, the following: (first row) Dr. Herbert Welte, Herman Hickman, honored guest Harry Jacunski, and VFW officers H. Troop and Dr. Albert Liebman; (second row) New York Giants all-pro center Ed Danowski, Frank Dornfried, John Leary, Charles "Chick" Shea, Ed Strader, Jack White, Lou De Filippo, Ed Creed, and Emil Jacques.

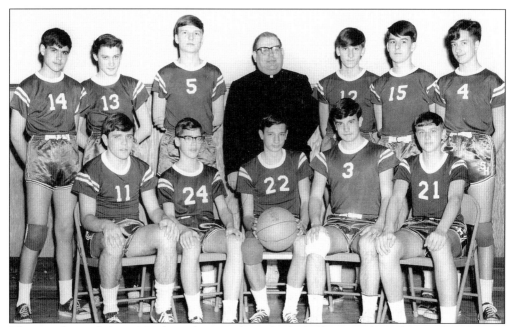

The members of the 1967 Sacred Heart boys' basketball team, dressed in red and white uniforms, are, from left to right, the following: (first row) Joseph Koziol, Robert Zadrozny, Kenneth Parciak, Dennis Przytulski, and Thomas Maciag; (second row) Stanley Florek, unidentified, Joseph Kiolbassa, Rev. Theodore Gubala, Stanley Pac Jr., Jan Rosinski, and Richard Magiera.

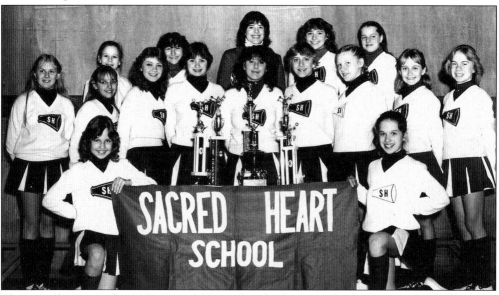

Three trophies give the 1983 Sacred Heart cheerleading squad reason to smile. Holding the school banner are Jennifer Provost (left) and co-captain Elizabeth Wojskowicz (right). Standing are, from left to right, the following: (first row) Marietta Krzyzanowski, Debbie Koluch, Margaret Korenkiewicz, Dorothy Kaczowka, Lisa Thistle, Christine Ends, Margaret Beards, Iwona Kasica (captain), and Diane Gawron; (second row) Christine Dalczynski, Mara Madera, Donna Macri (coach), Danielle Syntlo, and Suzanne Brocki.

Ten

KEEPING
TRADITION ALIVE

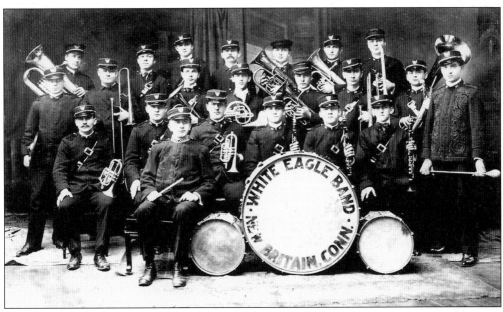

The White Eagle Band, one of New Britain's earliest Polish musical groups, is pictured here on a divided-back postcard. The format offers a clue to the photograph's date; postcards with a vertical line dividing the mailing address and message space were made between 1907 and 1916. The band's name honors the national symbol of Poland.

Frank Iskra (at left, playing the clarinet) and three unidentified band mates rehearse for a performance. Iskra was a well-known musician who played with a variety of local groups. A member of the New Britain Musicians Association, Iskra worked as a polisher at Landers, Frary & Clark when not making music.

Dressed in costumes of many nations, cast members of a 1920s-era production of St. Elizabeth's Theater Circle take their places on stage at the old Sacred Heart School. Performances by the group, founded in 1925, were an entertainment staple in the early years of New Britain's Polonia.

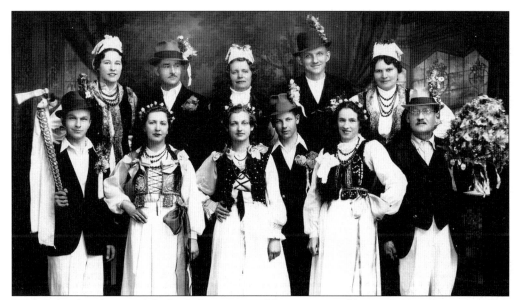

With Poland under attack by both Germany and Russia in World War II, New Britain's Polish community mobilized to provide whatever aid it could. Fund-raisers took many forms, including a theatrical reenactment of a Galician wedding. The cast of *Wesele z Ujanowic* (Wedding in Ujanowice) included sisters Valeria Filipek Lesczynski (first row, second from the left) and Wanda Filipek Dymkowski (second row, far left). Also identified is Andrzej Wysocki, standing to the right of Dymkowski.

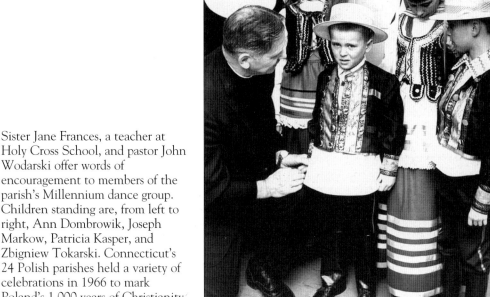

Sister Jane Frances, a teacher at Holy Cross School, and pastor John Wodarski offer words of encouragement to members of the parish's Millennium dance group. Children standing are, from left to right, Ann Dombrowik, Joseph Markow, Patricia Kasper, and Zbigniew Tokarski. Connecticut's 24 Polish parishes held a variety of celebrations in 1966 to mark Poland's 1,000 years of Christianity.

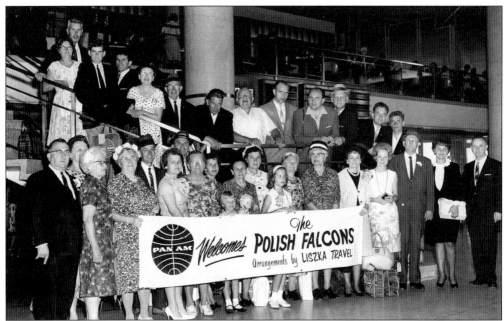

Standing in a terminal at New York's John F. Kennedy Airport, Edmund Liszka (first row, far right) waits with a group of local residents for their flight to Poland. In addition to owning a regionally known travel agency, Liszka was, for many years, the "Voice of Polonia" on local radio and Polish-language television programming.

The Borawski family gathers in the early 1950s for *Wigilia*, a traditional Christmas Eve supper. The five children in the foreground are, from left to right, Kathleen Borawski, William Spring Jr., Diane Borawski (behind William), Carol Spring, and Diane Bojniewicz. Adults pictured in this image are, from left to right, Emilie Bojniewicz, Stanley Borawski Jr., Mary Borawski, Anthony Brody Bojniewicz, Loraine Brody Bojniewicz, Franciszek Borawski, Mary Jagielski Borawski, William Spring, Helen Spring, and Agnes Borawski (with her back to the camera).

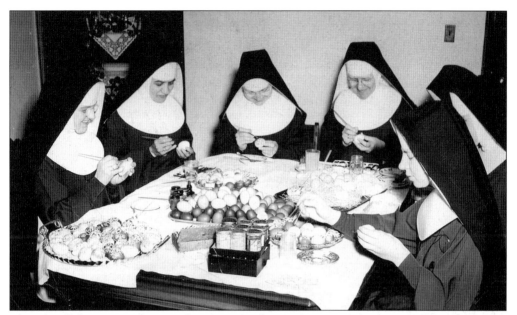

Their heads bent over their work, some Daughters of Mary of the Immaculate Conception create *pisanki* in the 1950s. The intricate designs of these traditional Polish Easter eggs, decorated with waxes and dyes, call for skill and patience. Seated are, from left to right, Sister Mary Clemens, Sister Justine, Sister Paula, Sister Alphonsa, two unidentified sisters, and Sister Cyril.

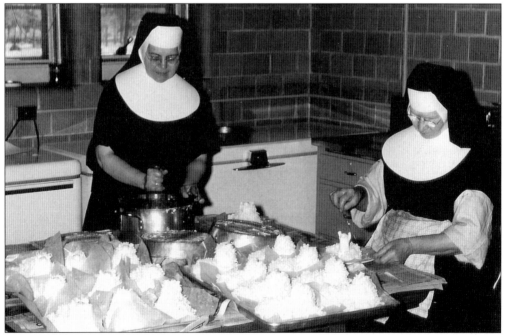

Sisters Lucianne (left) and Monica (right) hand-fashion traditional Easter butter lambs in the Daughters of Mary convent kitchen on Osgood Avenue. The lambs, bearing a flag emblazoned with a cross, adorn Easter dinner tables. They are among the foods placed in Easter baskets and blessed by priests on Holy Saturday, another Polish Easter custom.

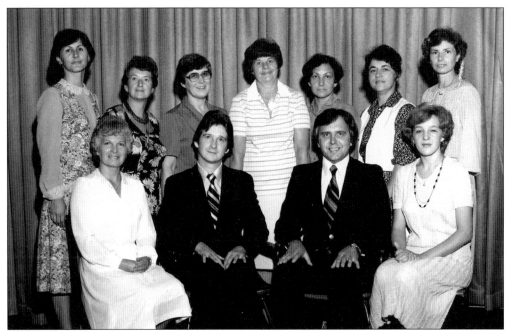

Faculty members of *Polska Szkola Sobotnia* (Polish Saturday School) gather for a photograph in 1980. Pictured are, from left to right, the following: (first row) Janina Wiktor-Wojcik, Mieczyslaw Bajek, Zygmunt Pietrzak, and Celina Panus; (second row) Wladyslawa Szczerbinska, Danuta Jachowicz-Bednarz, Stanislawa Gryglewicz, Jolanta Weglewska-Kierklo, Helena Michalska, Wanda Nowakowska, and Teodora Puchalska-Jurkowska.

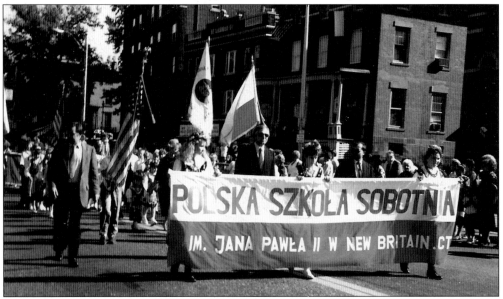

Marching in a Pulaski Day parade in Hartford are participants in New Britain's *Polska Szkola Sobotnia*. The school offers classes in the Polish language, literature, history, and culture; the curriculum is designed to help the community's youth maintain their Polish heritage. Immigrant parents established the program in 1960. With about 550 students, New Britain's Saturday School is one of the largest in the United States.

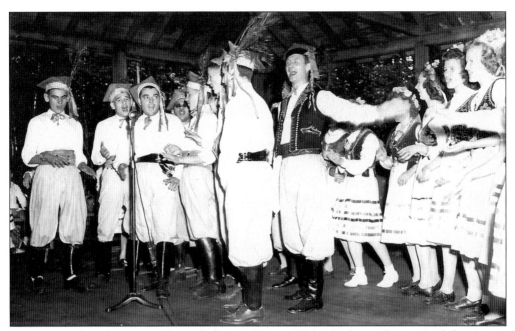

His *Krakowiak* garb accented by a dark vest, Roman Galinski (center) sings with his troupe during a 1949 *Dozynki* harvest festival in Paderewski Park in Plainville. Galinski, a native of Woloczyska, was a well-known dancer as well as an inventor and entrepreneur. He founded the Edro Corporation and developed a commercial laundry washer, for which he held two patents.

A *Dozynki* Festival committee ribbon pinned to her embroidered blouse, Barbara Kirejczyk samples a freshly baked *paczek*, a Polish-style, jam-filled doughnut. Kirejczyk, the daughter of Roman Galinski, was one of the principal figures who resurrected the popular festival in 1980 after some years' lapse.

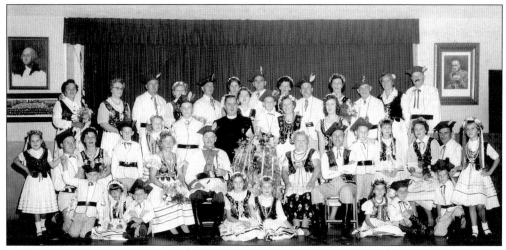

Parishioners of all ages, dressed in Polish folk costumes from the Krakow region, commemorate their 1957 Harvest Festival with a group photograph in the Transfiguration Polish National Catholic Church hall. Rev. Ludwik Kaczorowski is pictured with the group.

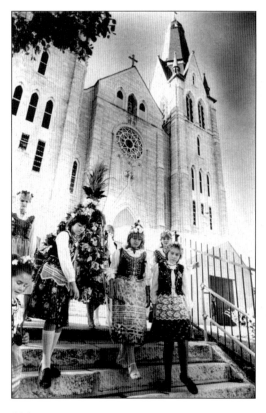

Sacred Heart Church towers in the background as girls in ethnic dress carry the *Dozynki* wreath down the steps to Broad Street in September 1984. Pictured are, from left to right, Alicja Swiatek, Elzbieta Chucik, Dorota Kaminska, Beata Chmura, Wioletta Depa, and Bernadetta Bukowska. The traditional harvest wreath, made from grains, wildflowers, and ribbons, is the centerpiece of all *Dozynki* displays. In rural Poland, it was the custom to offer the wreath and the fruits of the growing season to the lord of the manor as symbols of an abundant harvest.

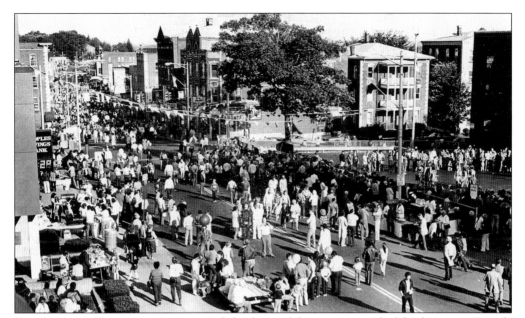

Broad Street, Connecticut's most Polish thoroughfare, teems with life during a *Dozynki* celebration in the early 1980s. The traditional Polish foods, crafts, choral and dance performances, and cultural displays of *Dozynki* attract thousands of festival goers to New Britain each year. This view, at the Grove Street intersection, also shows the People's Savings Bank sign at left and the Haller Post parking lot at right.

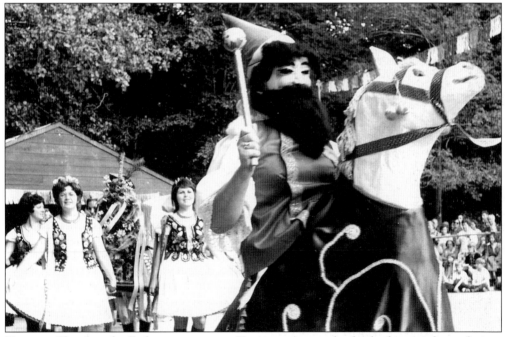

Krystyna Slowikowska-Farley represents a Tatar warrior as she leads the grand march in a Polonia Day celebration. She is dressed in a Lajkonik costume with a hobbyhorse fastened to the waist. The costume symbolizes the Poles' victory over the invading Tatars in 1241; the victory is commemorated in Krakow each spring with dancing and merrymaking.

127

Shown staffing an educational display at a conference of the Polish Genealogical Society of Connecticut and the Northeast are, from left to right, Matthew Bielawa, New Britain native Jonathan Shea, and John Orzel. The organization, headquartered in New Britain, was founded in 1984 to teach Polonia's descendants how to document their family histories and gather and create resources for Polish genealogical research.

One of New Britain's newest citizens, Malgorzata Toczko Miklosz, smiles as she displays her freshly acquired citizenship papers and a small flag of her adopted country after a naturalization ceremony in U.S. District Court in Hartford. She, her husband, Andrzej, and children Paulina, Joanna, and Martin emigrated from the Dabrowa Bialostocka area. The many young Polish families who settled in the city in recent years are the future of New Britain's Polonia.